Ways of Being

Advice for Artists by Artists

James Cahill

Contents

Introduction

James Cahill

How to be an artist? It seems an unanswerable question. The life of an artist rejects convention, lies apart from orthodoxies. There are no rules — no ways of being an artist. Or so we like to think. But the image of a life beyond the mainstream — which may be a fantasy of non-artists as much as an artistic pose — is not the whole story. Artists' lives, too, follow patterns. They strive towards milestones, hitting or missing them.

Art school, first shows, career setbacks, career pinnacles, hard graft and stagnation — these are just some of the stages and states of an artist's life. The interviews in this book trace these and many other moments, showing that there is no single route to becoming an artist (or, for that matter, remaining one). This book is not a 'how to' guide. Instead, it brings together multiple experiences, assembling fragments like a mosaic. It is a catalogue of possibilities and precautions, anecdotes and observations. Most of the artists interviewed for the project give an account of 'how I did it', rather than 'what you should do.'

The accounts in this book have been divided — anthologized — into a 'story' that progresses through some of the stages of an artist's life: childhood, art school, fledgling careers, the struggle or breeze of 'keeping going', and the prospect or reality of old age. The material has been gathered primarily from new interviews with artists, conducted in person or by phone. There is an emphasis on British artists — the book is partly the story of London's art scene, and how that scene has changed over the past 40 years. But the scope of the book also spirals outwards in time and place. The new interviews are interspersed with snippets from the art press, books and academic archives. These feature some of the giants of the modern European canon (from Rodin to Picasso) as well as older stories — reverberations of 'the long call from antiquity', Francis Bacon called it, such as the writings of the ancient art historian Pliny the Elder.

The result is an eclectic, shifting, disjointed array of voices — a dissonant chorus. Within it is much practical information for the aspiring artist, as well as philosophical advice: getting a studio, the role of artistic peer groups, economic survival, the benefits of having a gallery, the importance of not selling out. Then there is the matter of how it feels to create and destroy, succeed and fail. As the book progresses, certain accounts recur and develop, while elsewhere we receive only a momentary glimpse into a given life, at a given moment. In addition to the artists' testimony, the book features contributions from two art world insiders — a contemporary dealer and curator.

The aim of *Ways of Being* is to bring together voices of innocence and experience, perhaps with a stress on experience. In an art world where youth is worshipped and adored, this book celebrates those who have been in it for the long haul, and who have survived the fluctuations of fashion and taste.

I Youth

Youth

The artists, a historian and a philosopher△ ↓*

Edward Allington	Francis Bacon
Jo Baer	Phyllida Barlow
Lynda Benglis	Charlie Billingham
Louise Bourgeois	Billy Childish
Michael Craig-Martin	Salvador Dalí
Jesse Darling	Willem de Kooning
* Diodorus Siculus	Tracey Emin
Alberto Giacometti	Gilbert & George
Nick Goss	Maggi Hambling
Ian Hamilton Finlay	Damien Hirst
David Hockney	Rachel Howard
Tess Jaray	Allen Jones
△ Immanuel Kant	Anish Kapoor
Jeff Koons	Michael Landy
Leonardo da Vinci	Sarah Lucas
Gustav Metzger	Bruce Nauman
Chris Ofili	Yoko Ono
Philippe Parreno	Joyce Pensato
Pablo Picasso	Larry Poons
Fiona Rae	Mary Reid Kelley
Dieter Roth	Richard Serra
Conrad Shawcross	David Shrigley
Luc Tuymans	Vincent van Gogh
Mark Wallinger	Issy Wood

Star signs

Capricorn ♑
22 December–19 January

6 ↓
Louise Bourgeois
Joseph Cornell
Marsden Hartley
Tess Jaray
Thaddaeus Ropac
Issy Wood

Gemini
21 May–20 June

♊

1 ↓
Damien Hirst

Pisces ♓
19 Februar
–20 March

Aquarius ♒
20 January
–18 February

5 ↓
Derek Jarman
Jeff Koons
Yoko Ono
Jackson Pollock
Lawrence Weiner

Virgo ♍
23 August
–22 September

4 ↓
Carl Andre
Michael Craig-Martin
Allen Jones
David Shrigley

Taurus ♉
20 April–20 May

7 ↓
Salvador Dali
Willem de Kooning
Immanuel Kant
Dante Gabriel Rossetti
Dieter Roth
Jenny Saville
Conrad Shawcross

Scorpio ♏
23 October–21 November

9 ↓
Francis Bacon
Lynda Benglis
Charlie Billingham
Maggi Hambling
Ian Hamilton Finlay
Sarah Lucas
Pablo Picasso
Auguste Rodin
Richard Serra

Leo ♌
23 July–22 August

6 ↓
Jo Baer
Marcel Duchamp
Howard Hodgkin
Jenny Holzer
Giorgio Vasari
Andy Warhol

ibra ♎
3 September–22 October

↓
ic Fischl
'inslow Homer
nish Kapoor

Cancer ♋
21 June–22 July

4 ↓
Edward Allington
Tracey Emin
Philip Guston
David Hockney

↓
lberto Giacometti
ick Goss
hantal Joffe
hris Ofili
arry Poons
iona Rae
obert Rauschenberg
scar Wilde

Aries ♈
21 March–19 April

5 ↓
Phyllida Barlow
Leonardo da Vinci
Gustav Metzger
Grayson Perry
Vincent van Gogh

Other ×

1 ↓
Jesse Darling*

Sagittarius ♐
22 November
–21 December

5 ↓
Billy Childish
Helen Frankenthaler
Bruce Nauman
Ged Quinn
James Rosenquist

Once upon a time
and a very good time it was...

Childhood is a state that many artists never leave behind, at least in their imaginations. Others spend their lives striving to get back to it. Picasso once claimed: 'It took me four years to paint like Raphael, but a lifetime to paint like a child.' Since Romanticism, artists have sought to regain the clarity and artlessness of childhood, or what John Ruskin extolled as 'the innocence of the eye... a sort of childish perception'. For Picasso and other moderns, this meant the banishment of tradition. Today, the stock response to art that seems too guileless — too innocent to be true — is that 'a child could have done it'. So childhood has become a metaphor, good or bad, for what artists do — or how they see.

But what of artists' actual childhoods? Picasso's statement reflects the allure of seeing the world through the eyes of a child, but also the difficulty of returning to that germinal moment. Childhood experiences are hard to retrieve — tinted by what came later, or shrouded by layers of fiction and forgetfulness. Yet as Picasso suggested, childhood is a touchstone. However distorted by memory, it remains formative. It is through their earliest memories that artists trace (or construct) their imaginative origins. Childhood is the foil against which to make sense of adulthood — of life in the present.

Take Leonardo da Vinci's story of being visited by a vulture as a small boy. In the midst of his scientific notes, Leonardo wrote of the bird swooping down to his cot, prising open his mouth with its tail, and flicking the tail against his lips. For Sigmund Freud, this betokened a 'passive homosexual fantasy' and concealed the memory of being wet-nursed: the tale harboured evidence of the artist's psychic and sexual development. It hardly seems to matter whether the fable is true.

Even without the tools of Freudian analysis, it is easy to see how childhood experience shapes and authenticates later life. It offers clues to creativity, or material for later mythologies. Certain stories have become central to artists' personae: Michelangelo's boyhood training in the garden of Lorenzo de' Medici; Picasso's prodigious talent; Jackson Pollock watching his father urinate on a stone; Francis Bacon being whipped by his father's grooms; Frida Kahlo's near-fatal bus accident, at the age of 18, on a September afternoon in Mexico City.

What do artists remember – or think they remember – of their earliest lives?

'My earliest memory is slipping out of my mother's thighs'

Yoko Ono

Salvador Dalí
1904–1989

The intra-uterine paradise was the colour of hell, that is to say, red, orange, yellow and bluish, the colour of flames, of fire... *1*

My earliest memory is slipping out of my mother's thighs and looking at surgical instruments on a table in an operating theatre. Many people do remember their births, but they deny it. *2*

Yoko Ono
b.1933

Pablo Picasso
1881–1973

In those days, doctors used to smoke big fat cigars, and my uncle was no exception. When he saw me lying there he blew smoke into my face. To this I immediately reacted with a grimace and a bellow of fury. *3*

When I was born, they thought I was dead... I just rolled out, small and yellow with eyes closed. I didn't cry. But at the moment of my birth into this world, I somehow felt a mistake had been made. I couldn't scream or cry or argue my case. I just lay motionless, wishing I could go back where I'd come from. *4*

Tracey Emin
b.1963

Leonardo da Vinci
1452–1519

It seems that it had been predestined that I should occupy myself so thoroughly with the vulture, for it comes to my mind as a very early memory, when I was still in the cradle, a vulture came down to me, he opened my mouth with his tail and struck me a few times with his tail against my lips. *5*

My mum got pregnant. It was the first time she ever had sex with anyone, and he didn't want to know, so she moved to Bristol. *6*

Damien Hirst
b.1965

THE TAPESTRIES OF THE RENAISSANCE WERE VERY SEXY — GENITALIA EVERYWHERE!

Louise Bourgeois

'I thought: "I'm going to study this a bit"'

Edward Allington

Conrad Shawcross
b.1977

I was always taken to art galleries and museums when I was a kid. My stepfather was a painter and taught me to draw. In contrast to my mother and father, who both wrote, I was drawn to the art studio, and to the feeling of that environment — the smell of it, the physicality of it. I remember when I was about 5 seeing an Andy Goldsworthy sculpture on Hampstead Heath. He was trying to make an ice arch in the middle of the winter [*Ice Arch*, 1985], when one of the ponds was frozen. This guy, who I thought was old at the time (he was probably only in his twenties) was building an arch, and then it collapsed at the last minute, when he was pulling out all the supports.

I was brought up a Catholic and was an altar boy... I believe in God, but I'm not dominated by it. *7*

Chris Ofili
b.1968

Edward Allington
1951–2017

I was brought up as a Jehovah's witness. A lot of witnesses are very nice people, but it's a mad religion. I didn't believe it, although there was huge pressure to. I thought: 'I'm going to study this a bit.' I did a lot of reading, and discovered that Christ was a historical figure crucified in the time of Tiberius. That was the beginning of my interest in classicism. I now call myself an atheist Jehovah's witness.

During the war we lived in the depths of the English countryside, in Worcestershire, a place of wild and soft beauty that even the excesses of the twentieth century couldn't eradicate. For many years there was nothing in my surroundings that wasn't exactly as it had been 200 years before. My parents had escaped from Vienna just before the war and brought with them their rather exceptional culture, so the idea of being an artist and spending the evening drawing the landscape around me seemed natural to them. Mostly I drew fields with the hedges that divided them, and of course there were far more then than there are now, since farming became 'rationalized', and it has occurred to me recently that perhaps that was the start of my interest in what you might call the geometry of nature.

Tess Jaray
b.1937

Francis Bacon
1909–1992

My father was very narrow-minded. He was an intelligent man who never developed his intellect at all. *8*

Sarah Lucas
b.1962

Looking back at my childhood it's not a million miles away from something Dickens might have written. People spilling out of public bars. Slums. Fish and chips. Children playing on the street all day. A half-way house for borstal boys and scallywags. The old whore in the hotel opposite. [9]

I disliked him, but I was sexually attracted to him when I was young. When I first sensed it, I hardly knew it was sexual. It was only later, through the grooms and the people in the stables I had affairs with, that I realized that it was a sexual thing towards my father. [10]

Francis Bacon

Billy Childish
b.1959

My school report said: 'He would do better to worry about the essentials of reading and writing rather than the origins of obscure modern artists.'

My mother was a successful commercial artist. She was very stupid, but very talented and shockingly competitive. It's one of the reasons I have a science background. She was good at art and I wasn't. My father was scientific, so I got his intelligence. I didn't want to be an artist because my mother was always telling me I was no good.

Jo Baer
b.1929

Pablo Picasso

My first drawings could never have been shown at an exhibition of children's drawings. I lacked the clumsiness of a child, his naivety. I made academic drawings at the age of 7, the minute precision of which frightened me. [11]

I keep returning to a moment when I was 5 years old and just learning what reading was. I was reading this book and, at first, I was spelling out all the letters: one letter, then two letters, and so on. Then suddenly I had this picture in my head from the word. It was purely a magical moment. Collaborations can convey these kinds of moments in art. [12]

Philippe Parreno
b.1964

'I made academic
drawings at the age of 7'

Pablo Picasso

I REALIZED AFTER A COUPLE OF YEARS OF BUMMING AROUND THAT I KNEW NOTHING.

Joyce Pensato

> '**Learning to think and speak as an adult was fascinating to me**'
>
> Jo Baer

Nick Goss
b.1981

I remember making a painting at school aged 15. It was the first time I started working on something without a fixed idea of what it was going to be, and experienced being completely subsumed in a process. I kept painting interlocking concentric blue and green waves to build up an enormous whirlpool of water. The Blaue Reiter group — artists like Franz Marc and Wassily Kandinsky — were a recent discovery and I loved their approach to rendering organic forms in nature: the movement seemed so rich and with so much feeling of risk and tension. I wouldn't have articulated it at the time, but losing yourself in something until you connect into a more universal process was a revelation. I still have the painting with my folks in Bristol and remember wanting to chase that feeling.

Billy Childish

I was looking at Bacon and Warhol and Rothko when I was 11, and I was well versed in Modernist art from a young age. I would look around at these prissy people putting their hands up at school and asking permission to do things — and that wasn't the world I wanted. Not that I was a yob or anything. I was quite a refined child.

Edward Allington

When I was 7, I met a wonderful lady, Mary Burkett. She came into our school with various Roman artefacts. And being Miss Burkett — one of these unstoppable women in a thick skirt — she went and knocked on my parents' door and said: 'I want to take Edward on an archaeological dig.'

Louise Bourgeois
1911–2010

The tapestries of the renaissance were very sexy — genitalia everywhere! So my mother would cut out the genitalia, very delicately, with little scissors, and collect them. *13*

Salvador Dalí

When I was 7 years old, my father decided to take me to school. He had to resort to force; with great effort he dragged me all the way by the hand, while I screamed and raised such a commotion that all the shopkeepers on the streets we passed through came out on their doorsteps to watch us. *14*

16

Youth

—

Then, when I was a teenager, I saw a big seminal show by Bill Viola at the Whitechapel. There was a triptych of videos — his wife giving birth, his mother dying, and a body suspended in water between them.

Conrad Shawcross

Jo Baer

Learning to think and speak as an adult, when I was about 16 years old, was absolutely fascinating to me — the realization that there was something there beyond lipstick.

As a teenager I suddenly, and for the first time, had a lot of friends. This was the best thing that ever happened to me. Especially having some intelligent friends. I left school, aged 16, full of excitement at the prospect of being free. I spent a lot of days listening to records, smoking and drinking and talking. Over the course of a year it started to run out of steam. I realized that there has to be some action ongoing to communicate about. This provided my initial motivation to get into art. *15*

Sarah Lucas

'I kept painting interlocking concentric blue and green waves'

Nick Goss

Joyce Pensato
b.1941

I realized after a couple of years of bumming around that I knew nothing.

The Brecknock pub had live music every night. It was dense with hippies. Deep in the room they smuggled in their own scrumpy, and smoked pot. I was a half pint in my sister's Afghan coat. Staying out of eyeshot of the barmen. Islington wasn't too gentrified then. In fact it was rough. *16*

Sarah Lucas

Becoming an artist

Artistic beginnings are traditionally stories of training, hard graft and precocious talent. But as art has ceased to be a hard-and-fast category, the idea of what it means to be an artist has expanded and diversified. The American artist Allan Kaprow argued in his 1960 'Manifesto' that the decision to be an artist is a process of reconfiguring the world, and redefining one's perceptions, as much as a self-affirming stamp: 'The decision immediately establishes the context within which all the artist's acts may be judged by others as art, and also conditions the artist's perception of all experience as probably (not possibly) artistic.' Does a person become an artist in a moment of epiphany, or through a gradual realization? For many, being an artist was never a conscious decision. It is an indelible aspect of self. Others claim not to be artists at all, rejecting the very label.

I wasn't an artist when I was young. I don't even know if I'm an artist now. **Larry Poons**
b.1937

Jo Baer I ended up as an artist when I discovered that I would be second-rate at everything else.

Surpassing all others by natural ability, Daidalos pursued with zeal the art of building and also of fashioning statues and carving stone... In the production of statues he so excelled all other men that later generations preserved a story to the effect that the statues which he created were exactly like human beings. **Diodorus Siculus**
90–30 BC

'I ended up as an artist when I discovered that I would be second-rate at everything else'

Jo Baer

Louise Bourgeois I became a sculptor because it allowed me to express — this is terribly, terribly important — it allowed me to express what I was embarrassed to express before. *17*

Being an artist was something I had to do. It was within me from when **Joyce Pensato**
I was a child. My father was my first mentor: he encouraged art in the family. As a teenager, it was the only thing I could do. I felt that this was me. I'm from that working class generation where you had to have a job. My brother was a commercial artist, and so I thought, 'Well, I'll do the same thing'. This was the late 1950s, when young ladies did fashion illustration or record covers. I loved drawing, and at the time I really loved doing fashion drawings, but I was really bad at it. My problem was that I never liked putting details in. Then a teacher in high school said: 'You don't have to be a commercial artist. There's this whole other thing: being a painter, being in the fine arts.' That was the first good advice I got — that you could be something else in the arts. It opened the door for me.

Issy Wood 'Being an artist' only became a feasible concept when I was on my BA
b.1993 and worked as a studio assistant to Allison Katz, seeing that she was not only able to pay her rent but also doing all the conventional stuff like getting married and listening to Radio 4 and eating hummus. Before then I think I really thought you had to be dead before you made a living. I figured I'd go into advertising at some stage.

[I]t was more logical to be a designer or a commercial artist. I didn't intend to be really a painter. That came later. *18*

Willem de Kooning
1904–1997

Tess Jaray

There are two kinds of artist: those that are born that way, and those that come to it through interest in the subject. I am certainly in the first category. It's something I did since I was old enough to hold a pencil. I never considered doing anything else; the fact that I would one day have to earn a living didn't really penetrate my childish brain. I'm not certain that it has to this day. Possibly artists have to delay the process of growing up even more than other people, otherwise they could be faced with the impossibility of what they are attempting to do.

At the age of 10 or 11 I had a great ambition to be a missionary. *19*

Ian Hamilton Finlay
1925–2006

Luc Tuymans
b.1958

I always drew a lot as a kid, so I knew my ability was in the visual field. But of course, you don't become an artist just like that. At first, I thought of becoming a graphic designer. It was my professor of drawing, who was a sculptor, who convinced me to take the step to become an artist when I was 18.

'In my tea breaks, I read books on Fauvism'
Billy Childish

Anybody, seriously, can be considered an artist, no matter what they do. It's a self-generating definition — what people feel they are regardless of other criteria. It's not a sociological term. If you say you're a dentist, you're a dentist: you work on teeth. You have to go to school in order not to kill people when you work on their teeth. There are absolute things that you have to learn. But there are no rules in art.

Larry Poons

Jo Baer

I was trying to finish a Master's degree, and I realized that I could do all the academic stuff — but that I could never be original. I decided I would go to architecture school or be a film director. I went to Hollywood and worked as a script girl on television and film, but I was rubbish at it. At the age of 28, recently divorced and with a child, the only thing I could do was work as an artist. There was no choice, even. I stepped into it. I didn't want to be an artist, but I didn't want to be poor.

I gave up painting by 16. I secretly thought I would have been Rembrandt **Damien Hirst**
by then. *20*

Billy Childish I went to a very rough secondary modern school, although I came
from an artistic family. I never did O-levels or A-levels. I wasn't allowed
to apply even to the local art school. I ended up working up in a naval
dockyard at Chatham with a stonemason, where I made lots of drawings. In my tea breaks,
I read books on Fauvism and made Fauvist paintings of the people I worked with.

You can only get better if you do what you can do. The thing you can **Larry Poons**
do best — that is what you have to pursue. It's the only way you're
going to improve and excel.

Mark Wallinger I always wanted to be an artist, ever since I was a little kid. But I probably
b.1959 had a very imperfect grasp of what that was.

'The only rule in art
is genius'
Larry Poons

I was still very young and trying to be a painter, and *Las Meninas* [by **Richard Serra**
Velázquez] just knocked me sideways. I looked at it for a long time b.1939
before it hit me that I was an extension of the painting. This was
incredible to me. A real revelation. *21*

Mark Wallinger It's not for oneself ever to think: 'Now I'm an artist.'

When I was really young, I wanted to know about death and I went to **Damien Hirst**
the morgue and I got these bodies and I felt sick and I thought I was
going to die and it was awful. *22*

Larry Poons If you're trying to define who an artist is, there are maybe two or three
artists every hundred years, in the world's history. Now that's the
way I take 'artist'. Somebody who wears a beret can call themselves
an artist if they want, because they wear berets. Inadvertently, that guy might end up scrib-
bling letters that become a masterpiece. I like to think sometimes that everybody who has
a drinking problem, and becomes violent when they're drunk, will grow into an artist of the
calibre of Jackson Pollock. The most moronic person can still become Shostakovich. There are
no rules in art. It's like the guy who said that the only rule in art is genius. That's the only rule
that exists.

I GAVE UP PAINTING BY 16. I SECRETLY THOUGHT I WOULD HAVE BEEN REMBRANDT BY THEN.

Damien Hirst

Jesse Darling
b.1981

I always knew I wanted to be an artist, but didn't have the word for it, and anyway it wasn't allowed. But I knew that I would need to find something in which I could do more or less what I wanted — I mean needed to do — while somehow getting paid. And not wear a suit nor answer to a boss nor turn up every day at nine. But of course I did most of those things, except the suit-wearing part, for a long time, until I was ready to come out of the closet. I have come out as many things, but coming out as an artist was one of the hardest.

Genius is the talent (natural endowment) that gives the rule to art. Since talent is an innate productive ability of the artist and as such belongs itself to nature, we could also put it this way: Genius is the innate mental predisposition (ingenium) through which nature gives the rule to art. *23*

Immanuel Kant
1724–1804

'I have come out as many things, but coming out as an artist was one of the hardest'

Jesse Darling

Damien Hirst

And I went back and I went back and I drew them. And the point where death starts and life stops, for me, in my mind, before I saw them, was there. And then when I'd seen them and I'd dealt with them for a while, it was over there again. It's like I was holding them. And they were just dead bodies. Death was moved a bit further away. *24*

It was a gradual development but it was really more of a psychological attitude... So I styled myself as an artist and it was very difficult. But it was a much better state of mind. *25*

Willem de Kooning

Mark Wallinger

The artist Keith Wilson likened that moment to trying to go to sleep: you assume the position and close your eyes and do all the things that mimic sleep, until finally it might happen. I suppose you're an artist if you're bold enough to stick it somewhere and say: 'Hey, look at this.'

... there are many things which one must believe and love. There is something of Rembrandt in Shakespeare, and of Correggio in Michelet... If now you can forgive a man for making a thorough study of pictures, admit also that the love of books is as sacred as the love of Rembrandt, and I even think the two complete each other. 26

Vincent van Gogh
1853–1890

Gustav Metzger
1926–2017

When I was young I wanted an art that would lift off, that would levitate, gyrate, bring together different — perhaps contradictory — aspects of my being. 27

When I was young I wanted to become a real artist. Then I started doing something I felt wasn't real art, and it was through this that I became a well-known artist. 28

Dieter Roth
1930–1998

Diodorus Siculus

Talos, a son of Daidalos's sister, was given his education by Daidalos when he was still a boy... Daidalos, however, became very jealous of the boy, and anticipating that he would become more famous than his teacher, he murdered him.

'You're an artist if you're bold enough to stick it somewhere'

Mark Wallinger

I WENT AROUND SQUINTING MY EYES, LOOKING HARD AT EVERYTHING.

Lynda Benglis

Art school

A seminal moment, a phase of struggle, a blaze of precocious success — art school is a significant time in artistic careers, but signifies many different things. Whatever the experience, virtually all today's successful artists went to art school.

So what is art school for? For more than three centuries, the art academies of Europe instructed painters and sculptors according to established 'classical' precepts — students learned from nature and the masterpieces of ancient art. Then art schools pushed back against tradition and pluralized. When, in 1861, Gustave Courbet received a petition from a group of rebel students at the École des Beaux-Arts, asking him to open a studio and teach them Realism, he replied: 'I cannot teach my art, nor the art of any school whatever, since I deny that art can be taught... I maintain that art is completely individual, and is, for each artist, nothing but the talent issuing from his inspiration'. [29] More than 100 years later, in 1972, the students at the Munich Academy of Art rioted and smashed the school's collection of classical plaster casts to pieces: the school was a reliquary of stifling forms and redundant precepts — an authority to be rebelled against.

The nature and function of art education has continued to shift. In the 1990s Goldsmiths College, the seedbed of the Young British Artists (the heirs to the iconoclasts of Munich), was regarded in some quarters as a pernicious influence, responsible for the destruction of art education and symbolic of a wider malaise. Art critic Brian Sewell, one of the fiercest critics of contemporary art and art schools, singled out the Goldsmiths teacher Michael Craig-Martin for blame: '[He] maintains that art can be found anywhere and made of anything... By his tokens, art can be made by anybody... he has only himself and other teachers of his ilk to blame for the Government's hostility to art.' Strong words, summing up a popular (or populist) belief that art schools had lost their quality and purpose by the end of the twentieth century.

Since 2000 schools have continued to move towards a broader, more fluid model. Is 'art school' a contradiction in terms, in an age when art is no longer taught according to universal principles? Or does it continue to impart something more important, and more subtle, than dexterity with a pen or brush or chisel — a set of coordinates, a circle of peers, a diverse store of knowledge, a sense of identity?

Larry Poons

A school can put a roof over your head if you don't have a room at home, or a place to paint or draw or design things. It can put you in touch with other people who may or may not share your inclinations.

Tess Jaray

In the UK it really is important to go to art school, for two reasons. The first is simply that you will learn about your subject in a way that is almost impossible by yourself: through practice and learning and observation. No different really from other academic subjects. You need guidance, doors to knowledge opened, understanding of what it means to be an artist. And what art might be. You have to be shown how to use materials — even if it's film or video or anything not previously considered as art — and above all you have to learn to see. That is the most difficult thing of all. Not just to look, but to see and understand the visual world in which you live, and with any luck what you might be able to do with it.

Fiona Rae
b.1963

Art school shows you what you are doing back to yourself; that's its amazing function.

Tess Jaray

The other reason is of equal importance: to study all these things with your peers who are equally interested. An art student will learn as much from the other students as from the tutors, sometimes more. And though there isn't a ready-made place in the art world for the leaving student, in the way there may be for someone who studies business or engineering, as a group, or as part of a generation, it is more likely that you can continue. The so-called art world is not an easy place to break into by yourself.

I

Youth

27

'Above all you have to learn to see'
Tess Jaray

Larry Poons

There is nothing for an art school to teach, because there's nothing that can be taught if your ambition is to be an artist as great as Velázquez — just pick your favourite: no school can teach you how to be that good. Otherwise we'd all go, we'd all learn it, and we'd all be better artists.

'Schools do not teach you talent, whatever that is'

Larry Poons

There's a kind of curious mythology about being self-taught. I guess it's based on Francis Bacon (who I do think is a great artist, but also hugely overrated. If you knocked off 25 per cent of his value, he'd still be great). Art school makes a massive difference. That's why I work at the Slade. It's not about a paradigmatic system — or about saying, 'that's good, that's bad'. There are different systems. I think the whole point is to help young artists to grow, and do stuff that you've never seen before. Sometimes I go into the school and think: 'What the fuck is that?' But that's what it should be.

Edward Allington

Jo Baer Art schools — I think they're dreadful.

It's strange, really, that art is one of the few areas in which people even question whether you wouldn't go and train in it. There's no way you'd expect to be a linguist without learning the language. You wouldn't expect to be a historian without studying history. It's weird, the idea that you can just go and make it up.

Fiona Rae

Jo Baer They don't even teach you to draw anymore. They just teach whatever is 'hot', the ones here in Holland, and in America and London. They teach concept art which only includes painting, so that the students use painting to express the concepts they have. They don't learn anything about painting. This is why there's so much shit around.

Art school is essential and at the same time it's incredibly brutal. **Mark Wallinger**

Jo Baer I never went to art school. I am blessed with having learned how to think. Artists don't know how to think, most of them. You may not notice it, but I do, because they're part of my tribe. They don't know how to prioritize. They don't understand what the hell they're doing. I find it shocking.

Fiona Rae

Even if you're busy rejecting ideas, at least you know about them. And you should know about them. It's like the law: ignorance is no excuse.

Larry Poons

If your ambition is to be able to write well, there's no school that is going to be able to teach you that, if you're talking about Ibsen, Shakespeare, Marlowe. Now, if you're talking about writing for a sitcom, there are forms there that you can learn: you can learn to write something that works on TV, or even on the stage; but if you're looking to be as great a playwright as Sophocles, what school is going to teach you that?

Mark Wallinger

At the age of 19 you've got three years at the end of which you're expected to come up with an original body of work. It doesn't happen if you read English at university, does it? You're not expected to come up with that. It's an enormous amount of pressure on people who are young and don't know a whole lot about life. But it's a kind of crucible.

Charlie Billingham
b.1984

My parents are and always were supportive, and that made it easier for me to pursue my ambition, even when teachers and some of my peers were trying to dissuade me from going to art school. I remember a lot of rhetoric about how unwise it would be to go to art school and how it might be better to study a 'proper subject'. I'm very glad I ignored that advice.

David Shrigley
b.1968

Education takes many forms, and art education is distinct from the rest of the academic world. I think the art student is a sort of academic outcast, in the sense that — in 'teaching art' — you're facilitating learning rather than imparting knowledge. There isn't really another subject like Fine Art in that respect. So I think that it is important to have an education in art, but sometimes that education is really just being left alone in the studio for a long period of time.

Larry Poons

Schools do not teach you talent, whatever that is. Some people want to call it a God-given gift. It's not the person's fault that they're that good at it. It wasn't Mozart's fault that he was that good.

'You wouldn't expect to be a historian without studying history'
Fiona Rae

LOSING YOURSELF IN SOMETHING UNTIL YOU CONNECT TO A MORE UNIVERSAL PROCESS WAS A REVELATION.

Jesse Darling

Jeff Koons
b.1955

My first day in art school, we went to the Baltimore Museum and at that moment I realized how naive I was. I didn't know who Braque was. I didn't know Manet. I knew nobody. I knew Dalí, Warhol, and probably Rauschenberg, and Michelangelo, but I had no sense of art history. *30*

During this time of dissuasion from going to art school, I remember some great advice from my art teacher at school. He said that if I didn't go to art school and went to study the history of art instead, that I would spend all day every day looking at other people's art and not being able to create my own, and that that would be incredibly frustrating.

Charlie Billingham

Salvador Dalí

My father wrote me on several occasions that at my age it was necessary to have some recreation, to take trips, go to the theatre, take walks about town with friends. Nothing availed. From the Academy to my room, from my room to the Academy, and I never exceeded the budget of one peseta per day. *31*

Goldsmiths educated me in the history of art, and provided a space in which to experiment and figure things out. I can't imagine not having gone to art school. But Goldsmiths was a difficult place. You were on your own, and there was no structure. You had to write one essay a year. Coming from an academic background at school, I floundered badly at first, because I thought: 'Where's my timetable? Where are the staff telling me what I need to do, and how to achieve it, and why can't I get 90 per cent?' No one cared! You were on your own. I nearly dropped out at one point because I couldn't cope.

Fiona Rae

Michael Landy
b.1963

The thing with Goldsmiths was that it just allowed us to think for ourselves.

I had a terrible time at degree college. I was at an art college that was completely rudderless — it didn't seem to have much of an idea of ethos or teaching or anything. But it was three years of trying to do something, and being given permission to do that.

Mark Wallinger

Billy Childish

I walked into Saint Martin's on a course for people who showed particular ability. But then I wasn't allowed to go, because it was outside of the catchment area for Kent. So I went to the local college. I was big on Dada, and it wasn't considered very amusing at that time to make sex mobiles and that kind of thing. I was a figurative painter and made drawings, but I was very influenced by Kurt Schwitters. I was put on probation and wasn't allowed to finish the course.

When I started out in art school in the 1970s I did it just to exist, there wasn't a hope in hell of making a living from it. *32*

Anish Kapoor
b.1954

Billy Childish Then I got into Saint Martin's again as a painter in '78. I got in with a cardboard box full of collages. But the course was all about Abstract Expressionism, so I walked out. I was out for two years, and then [Margaret] Thatcher came in and put big pressure on dole queue people, so I reapplied in '80. I got back in, and that's when I became friends with Pete Doig: we were in the same year. He was the only guy who I was friends with because we both liked figurative painting, rock and roll music, and Charles Bukowski.

When I went to the Slade, I learned to understand the real seriousness **Tess Jaray** behind the making of art, and what it might mean to spend one's life believing in its importance. Whatever kind of an artist I am now comes from those three years, in the company of others who felt the same; that hasn't changed much.

'Whatever kind of an artist I am now comes from those three years'
Tess Jaray

Billy Childish So art school was important, but mainly in terms of planning being in bands, and using Xerox machines. The truth of it is, we weren't taught anything. All they tried to do was constrain me, continually.

I was lucky in that the art school I went to, the Ruskin, was part of a **Conrad** university. That had an important effect on the type of work I made. **Shawcross** It made me look beyond the context of art history and art itself. I was much more interested in scientific ideas, and the history of ideas — a more philosophical approach. At the Ruskin, they had a lot of courses about the history of medicine, and things like the history of the soul and the body. All those kinds of areas where belief and empiricism get a bit blurred — the subjective and the objective are on that threshold. I became interested in machines, contraptions and invention; in the history of machines that were once at the forefront of technology, and then became absurd objects from the past.

Bruce Nauman I really entered the whole thing with a lot of ignorance about art, especially
b.1941 about contemporary art... *33*

Larry Poons In my six months in art school, and at high school when you had to take classes, there was always somebody who could 'draw' better than anybody else — so realistically that there was no way you could get even close. But they never could paint. The person that could draw the best was not the best painter of the group. School can teach you how to draw, to be a better draughtsman. But they can't teach you how to be a better painter, because there's nothing to teach about colour, but there's everything to react to.

This is the paradox: I got into art school four times on a 'genius course', **Billy Childish** and each time they said to me: 'Well, actually, you're not a genius. You're one of the worst students we've ever had.'

Phyllida Barlow At the Slade [from 1963 to 1966] we were taught to work from the figure, b.1944 it was compulsory. I wanted to reinvent what sculpture could be, to experiment with weird, non-sculptural materials. It would have been easier to have made a complete break with sculpture altogether, in the way that Terry Atkinson was doing with his Fine-Artz group, in relation to painting. *34*

'There's nothing to teach about colour, but there's everything to react to'
Larry Poons

At the New York Studio School I got all the stuff I needed: I got struc- **Joyce Pensato** ture, I got lifetime friends, it really shaped what I am — what I still am. The philosophy when I was there was that you drew like Giacometti or Cézanne, and you painted like de Kooning. That's my tradition. I keep that tradition.

Edward I was asked this great question the other day by one of our PhD **Allington** students at the Slade. She said: 'Well, what is heaven?' And I thought: 'That's a good question. What is it? I'll need to do a bit of work on that.'

I first went to Saint Martin's, which was then in Charing Cross Road, **Tess Jaray** at the edge of Soho. Soho as it was in its most Bohemian period with its dark side showing now and again. It was 1954, still very much a post-war period, and the change in culture was thrilling.

'We were taught how to draw, which is really being taught how to see'
Tess Jaray

Gilbert & George
b.1943, 1942

The whole of Soho was an amazing, vibrant, international place. The most famous bookshop in the world, and all the prostitutes and night bars and restaurants and pimps.

Tess Jaray

That added something very special to the education, which at that time was pretty good. We were taught how to draw, which is really being taught how to see, from the figure and other ways, how to build stretchers, how to understand perspective, how to make prints, as well as to attempt to analyse what we were doing.

David Hockney
b.1937

When I got to the Royal College of Art people used to mock me: 'Trouble at t'mill, Mr Ormondroyd', stuff like that. I didn't take any notice, but sometimes I'd look at their drawings and think: 'If I drew like that, I'd keep my mouth shut.' [35]

Lynda Benglis
b.1941

When I was at school, there was a young artist teaching there who said, 'look hard'. I didn't understand what looking hard meant. So I went around squinting my eyes, looking hard at everything. It wasn't the right advice in a way. I would say, think and emote.

Salvador Dalí

At the end of a year of libertinism I received notice of my permanent expulsion from the Academy of Fine Arts. [36]

Changing times: art school then and now ↓

Billy Childish

Going into art school after the Second World War would have been brilliant. There were things you had to learn, and you would be learning them with ex-servicemen. There would have been so much rigour, and none of the pressure there is now to be original. If I teach in art schools now, which I occasionally do, I find that the pressure on the kids is phenomenal. They actually tell them: 'At the end of this course you will be a practising artist.' They basically annihilate any of the inspiration that they bring into the school.

David Shrigley

At Glasgow in the 1990s, we had a lot of space and time, and the financial implications were non-existent. You could be completely ambivalent and not really know why you were going, and not end up with massive debt like students have these days. I actually got a grant to go to art school, never mind paying fees. The year that I left saw the first introduction of the student loan. So it was the end of halcyon days. I was in art school between '87 and '91. In every respect, art school was better when I went. The experience of teaching in art schools, off and on, and looking at the experience that students have now, has left me feeling very fortunate.

WHILE THEY DIDN'T NECESSARILY GET WHAT I WAS UP TO. I WAS SUPPORTED IN DOING IT.

David Shrigley

My college had a very good art history department and I lament the fact that now critical theory has become enshrined in courses. It's like a new academicism. In my day you searched through art history and traced your own lineages, and found affinities with artists going way back.

Mark Wallinger

Teachers, memorable and forgettable ↓

Billy Childish

The only person who taught me anything concrete was my art teacher at secondary modern, John Holborn. He impressed on me that I should learn to draw. I had largely ignored him, and it was only when I went to work at the dockyard — and saw life stretching before me — that I sat down and did 600 to 1000 drawings in six months.

'Have you ever heard the story of the blind man spending his life trying to read a cheese grater?'

Maggi Hambling

When I was at Camberwell, I used to have a little notebook in which I wrote down quotations that appealed to me from various artists. There was a quotation of Giacometti likening the process of making a painting or drawing to a blind man groping in darkness.

Maggi Hambling
b.1945

Alberto Giacometti
1901–1966

Un aveugle avance la main dans la nuit ('A blind man feels his way into the night').

And I went to Adrian Berg, who was the tutor at Camberwell at the time, and I said: 'Isn't it fantastic, a blind man groping in darkness?' And Adrian looked up, and said: 'Have you ever heard the story of the blind man spending his life trying to read a cheese grater?' And he cackled with laughter. That was one of the wonderful things about him as a teacher. Whatever you were passionate about, he turned it over straightaway.

Maggi Hambling

Gilbert & George We went to see Anthony Caro, one or two months after college with our new ideas. You had to have new ideas because you couldn't get a grant from the Arts Council, you can't do anything as two people. We were talking about the whole world as sculpture. And then he listened very politely and said, 'I hope very much that you don't succeed, but I rather think you might.'

Tess Jaray

Both [William] Coldstream and [Ernst] Gombrich were very strong presences at the Slade. Gombrich, whose last year of lecturing I was lucky to have caught, introduced us to Renaissance painting in the most powerful way imaginable. His lectures were always packed out, people were sitting in the aisles. I get very sad when I think that art students now aren't taught about all that any more, a real loss. And Coldstream was a fascinating man. Sometimes we would ask ourselves if he was a genius, and although many people said he was, we could never put our finger on precisely why we thought that. He always encouraged the students to develop in their own way, and was supportive of movements that he himself had no real interest in. He could also be hilariously funny, at coffee breaks his table was always full of people falling off their chairs with laughter.

Joyce Pensato Mercedes Matter, the founder of the Studio School, was an incredible woman. And there was a young teacher, Steve Sloman — his energy was fantastic. Philip Guston was also there sometimes. He was mostly in Boston and he would come in for critiques. Steve Sloman really looked up to Philip Guston, so it was a trickle-down effect.

Fiona Rae

It's important to have great artists teaching in schools because art's such a huge subject. There are many tiny tributaries, and sometimes they won't look very important — it's only later that you'll realize how important they were. And so there might be some artist telling you about a funny lesser-known area, that actually turns out to be a key part of art history.

'I hope very much that
you don't succeed,
but I rather think
you might'
Gilbert & George

Brian Catling, the Head of Sculpture at the Ruskin, was this larger-than-life performance artist, very much a practising artist, on the tail-end of the bell curve in terms of craziness. As a role model he was liberating, because he was making very unusual, unconventional work, which was good if you wanted to break down your preconceptions of what art was.

Conrad
Shawcross

'The secret is, you just have to keep going'

Fiona Rae

Fiona Rae

Michael Craig-Martin had a big show at the Whitechapel Gallery while we were students, and he told us: 'The secret is, you just have to keep going.' It's quite funny — the idea that you keep going, while everyone else just drops away or gives up, and then you're the last person standing, and you get your show.

I studied at Glasgow School of Art. There was a remnant of crusty old professors in certain parts of the school. They were a bit old school, in a bad way — a bit misogynist and not very accepting of conceptual art. And I guess the critical teaching wasn't that great.

David Shrigley

Fiona Rae

Richard Wentworth was very generous to the students at Goldsmiths — he would put interesting things in your pigeonhole. He was very much about connecting you with your interests: if he saw you doing a certain kind of work, he would bring you the book that related to it. Jon Thompson was really instrumental in making Goldsmiths the place that it was in that so-called golden age. I look back now and think, wow, I was so lucky.

But ultimately I was very lucky. My own teachers were very supportive. While they didn't necessarily get what I was up to, I was supported in doing it.

David Shrigley

IT WASN'T MOZART'S FAULT THAT HE WAS THAT GOOD.

Larry Poons

Life after art school

Is there life after art school? For many students, art school repre-sents both the beginning and end of their career as an artist. Work is made, exhibitions are hung, relationships are forged, and then — other realities come along. The end of art school is often the beginning of a different, more profitable path — teaching, curating, designing, dealing. No small number of today's leading art dealers began as artists. But for those who persevere with the calling, the early years are usually a leap into the unknown. The passage from learning to making a living is precarious — and for some, never-ending. As in Yves Klein's famous trick photograph *Leap into the Void* (1960 — where the artist seems to be flying off a wall, but also falling to the earth), the act of leaping into the unknown may be heroic or mad — or both.

'You must still find time to keep producing work'

Allen Jones

Previous generations always had something to fall back on for survival. My generation had teaching. The following generation had the dole. Then, by the end of the 80s, after Thatcher, there was no dole, or teaching, and the only hope now for young artists surviving is to try to make money from what they do. *37*

Michael Craig-Martin
b.1941

Sarah Lucas

I remember [at college] being encouraged to 'make another one of those' and feeling angry about it. Later when some of us were taken up by galleries it seemed to be on the basis of one idea or method of dripping paint or some such. It seemed phoney to me, I thought fuck it, I'll get out of it. Somehow that freed me up. *38*

People nowadays at art school feel that if they're not snapped up by White Cube or somewhere from their degree show, then they've had it. And then if they are, and say they 'paint a milk bottle', they've got to go on painting milk bottles. What the fuck? I've never been able to be told what to do.

Maggi Hambling

Mary Reid Kelley
b.1979

Try to get a residency. They are very competitive but it will give you a transitional cushion, and a place to expand on the dynamic feelings of liberation, of not being watched, that can come after leaving school.

The reason I did art was that I didn't want a job. I worked that out when I went into the dockyard. I realized I didn't want to work — although I did end up working at the mental asylum for a while, as a porter. So I basically did my painting on the dole for 15 years.

Billy Childish

Allen Jones
b.1937

Whatever you have to do to make a living you must still find time to keep producing work. At art school people are paid to care about you, afterwards, no one is. Despite teaching full time with a couple of hours' commute for over two years I resolved to paint at least four hours every night to stay in the race.

When I left Goldsmiths I was still waitressing in Soho (a job I did all through university). I remember I found it incredibly disheartening having a degree and still serving tables. It was 1991, there was a recession and everyone was applying for the same jobs, such as cloakroom attendant at the National Gallery.

Rachel Howard
b.1969

Fiona Rae

I left Goldsmiths in 1987. When you leave art school, it's like falling off a cliff into nothingness. From going every day into a lovely arena with people — from being part of a connected community of lively people — you go to a little space (mine was somewhere in the East End), a bit of a space behind a door in an unheated warehouse, where the other two or three people with studios often aren't there. You go into absolute lonely bleakness, unless you're lucky enough to set yourself up with a group of friends.

By complete serendipity a few months later, I was in our local pub in Brixton (where quite a few artists and gallery owners gathered at the time) with a friend I'd met at Goldsmiths [Damien Hirst]. He needed an assistant, someone to paint, and I said I'd do it — oblivious of what I was getting myself into. I was just helping a mate out — but a job connected with the arts was far better than a job that was just to keep the wolf from the door. I worked to pay my bills and buy materials for my own practice.

Rachel Howard

Louise Bourgeois

I thought New York was beautiful, a cruel beauty in its blue sky, white light and skyscrapers. I felt lonely and stimulated. *39*

When I left college, we had a four-week course which was titled, 'Is there life after art college?' And the short answer would have been no. But it did teach you things that I still remember like: never get a job that interests you too much, how to sign on, those sorts of things. The hardest thing is just keeping going, once you've left college. People I knew said, 'I'll do this job for a while and save up some money' — but that was the end of them. So that's the hardest thing.

Mark Wallinger

'When you leave art school, it's like falling off a cliff into nothingness'

Fiona Rae

NEVER GET A JOB THAT INTERESTS YOU TOO MUCH.

Mark Wallinger

Notes

1 Salvador Dalí, *The Secret Life of Salvador Dalí*, 1942 (New York: Dover Publications, 1993), 27 *2* Yoko Ono, quoted in Alice Fisher, 'This Much I Know', *The Guardian*, 19 September 2009 *3* Pablo Picasso, quoted in John Richardson with Marilyn McCully, *A Life of Picasso. Vol. 1, 1881–1906* (New York: Random House, 1991), 25 *4* Tracey Emin, *Strangeland* (London: Hodder and Stoughton, 2005) *5* Leonardo da Vinci, quoted in Sigmund Freud, 'Leonardo da Vinci and a Memory of his Childhood', 1910 *6* Damien Hirst in interview with Gordon Burn, 1992, reprinted in 'Damien Hirst and Gordon Burn', *The Guardian*, 6 October 2001 *7* Chris Ofili, quoted in Carol Vogel, 'Chris Ofili: British Artist Holds Fast to his Inspiration', *New York Times*, 28 September 1999 *8* Francis Bacon, quoted in David Sylvester, *Francis Bacon: Interviewed by David Sylvester* (New York: Pantheon Books, 1975), 71–72 *9* Sarah Lucas, *After 2005, Before 2012* (London: Sadie Coles HQ/Koenig Books, 2012) *10* Bacon, quoted in Sylvester, *Francis Bacon*, 71–72 *11* Picasso, quoted in Ingo F. Walther, *Pablo Picasso, 1881–1973: Genius of the Century* (Cologne: Taschen, 2000), 8 *12* Philippe Parreno in interview with Andrea K. Scott, *Artforum* online, 2002 *13* Louise Bourgeois (whose mother was a tapestry restorer) in interview with Henry Geldzahler, quoted in Joan Acocella, 'The Spider's Web: Louise Bourgeois and her Art', *The New Yorker*, 4 February 2002 *14* Dalí, *The Secret Life of Salvador Dalí*, 35 *15* Lucas, *After 2005, Before 2012* *16* Ibid. *17* Bourgeois, 'The Spider's Web' *18* Willem de Kooning in radio interview with David Sylvester, March 1960. See www.dekooning.org/documentation/words/content-is-a-glimpse *19* Ian Hamilton Finlay, quoted in 'Ian Hamilton Finlay', *The Daily Telegraph*, 28 March 2006 *20* Damien Hirst, quoted in Simon Hattenstone, 'Damien Hirst: 'Anyone Can Be Rembrandt', *The Guardian*, 14 November 2009 *21* Richard Serra, quoted in Sean O'Hagan, 'Man of Steel', *The Observer*, 5 October 2008 *22* Damien Hirst and Gordon Burn, *On the Way to Work* (London: Faber and Faber, 2001), 36 *23* Immanuel Kant, *Critique of Judgement* (1790), trans. James Creed Meredith (Oxford: Clarendon Press, 1911) *24* Hirst and Burn, *On the Way to Work* *25* Willem de Kooning in interview with David Sylvester *26* Vincent van Gogh, *The Letters of Vincent van Gogh*, ed. Mark Roskill (New York: Touchstone, 1997), 121 *27* Untitled note by Gustav Metzger, n.d., reproduced in Elizabeth Fisher (ed.), *Gustav Metzger: Lift Off!* (Cambridge: Kettle's Yard, 2014), 2 *28* Dieter Roth, quoted in Michael Kimmelman, 'Dieter Roth, Reclusive Artist and Tireless Provocateur, 68', *New York Times*, 10 June 1998 *29* Gustave Courbet, Paris, 25 December 1861. Reprinted in Linda Nochlin (ed.), *Realism and Tradition in Art: 1848–1900* (Englewood Cliffs, NJ: Vassar College, 1966). *30* 'Art Changes Every Day: Jeff Koons', Art21.org. See https://art21.org/read/jeff-koons-art-changes-every-day *31* Dalí, *The Secret Life of Salvador Dalí* *32* Anish Kapoor, quoted in Ossian Ward, 'Anish Kapoor and Richard Serra: Interview', *Time Out*, 13 October 2008 *33* Bruce Nauman, quoted in Michele De Angelus, 'Oral History Interview with Bruce Nauman', 27–30 May 1980. See www.aaa.si.edu/collections/interviews/oral-history-interview-bruce-nauman-12538 *34* Phyllida Barlow, quoted in Mark Godfrey, 'Learning Experience', *frieze*, 2 September 2006 *35* David Hockney, quoted in Tim Lewis, 'David Hockney: 'When I'm Working, I Feel like Picasso, I Feel I'm 30', *The Observer*, 16 November 2014 *36* Dalí, *The Secret Life of Salvador Dalí* *37* Michael Craig-Martin, quoted in Tim Adams, 'Michael Craig-Martin: "I Have Always Thought Everything Important Is Right in Front of You"', *The Observer*, 26 April 2015 *38* Lucas, *After 2005, Before 2012* *39* Louise Bourgeois, quoted in Richard D. Marshall, 'Interview with Louise Bourgeois', *Whitewall*, 23 August 2007

I Youth

II Breaking out

Edward Allington	Jo Baer
Lynda Benglis	Charlie Billingham
Billy Childish	Nick Goss
Raphael Gygax	Maggi Hambling
Ian Hamilton Finlay	Jenny Holzer
Rachel Howard	Tess Jaray
Allen Jones	Peter Liversidge
Sarah Lucas	Joyce Pensato
Larry Poons	Ged Quinn
Fiona Rae	Robert Rauschenberg
Mary Reid Kelley	*Thaddaeus Ropac
James Rosenquist	Jenny Saville
Conrad Shawcross	David Shrigley
Luc Tuymans	Mark Wallinger
Andy Warhol	Richard Wentworth

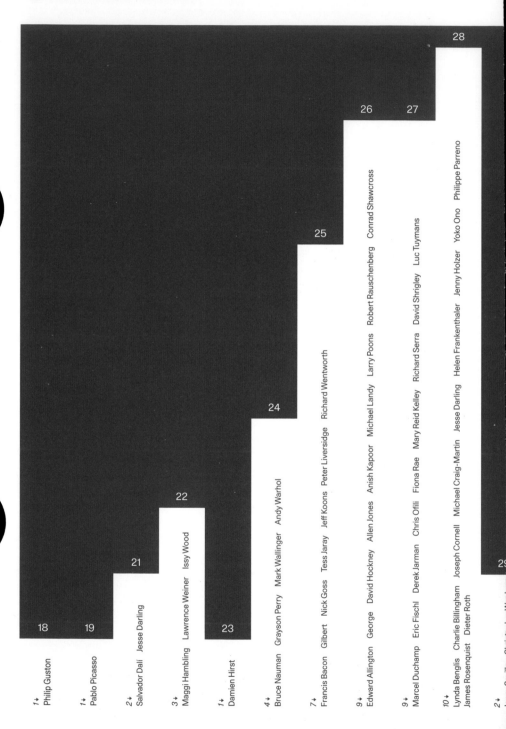

Age at first major solo show

28

26 27

25

24

22

21

18 19 23

Conrad Shawcross
Robert Rauschenberg
Larry Poons
Michael Landy
Anish Kapoor
Allen Jones
David Hockney
George
Edward Allington

Luc Tuymans
David Shrigley
Richard Serra
Mary Reid Kelley
Fiona Rae
Chris Ofili
Derek Jarman
Eric Fischl
Marcel Duchamp

Philippe Parreno
Yoko Ono
Jenny Holzer
Helen Frankenthaler
Jesse Darling
Michael Craig-Martin
Joseph Cornell
Charlie Billingham
Lynda Benglis
James Rosenquist Dieter Roth

Richard Wentworth
Peter Liversidge
Jeff Koons
Tess Jaray
Nick Goss
Gilbert
Francis Bacon

Andy Warhol
Mark Wallinger
Grayson Perry
Bruce Nauman

Issy Wood
Lawrence Weiner
Maggi Hambling

Jesse Darling
Salvador Dali

Pablo Picasso

Philip Guston

1↓ Philip Guston

1↓ Pablo Picasso

2↓ Salvador Dali Jesse Darling

3↓ Maggi Hambling Lawrence Weiner Issy Wood

1↓ Damien Hirst

4↓ Bruce Nauman Grayson Perry Mark Wallinger Andy Warhol

7↓ Francis Bacon Gilbert Nick Goss Tess Jaray Jeff Koons Peter Liversidge Richard Wentworth

9↓ Edward Allington George David Hockney Allen Jones Anish Kapoor Michael Landy Larry Poons Robert Rauschenberg Conrad Shawcross

9↓ Marcel Duchamp Eric Fischl Derek Jarman Chris Ofili Fiona Rae Mary Reid Kelley Richard Serra David Shrigley Luc Tuymans

10↓ Lynda Benglis Charlie Billingham Joseph Cornell Michael Craig-Martin Jesse Darling Helen Frankenthaler Jenny Holzer Yoko Ono Philippe Parreno
James Rosenquist Dieter Roth

2↓

29

First studio

The artist's studio has always had a split identity — as a daily reality and a romantic idea. The two roles can be hard to disentangle. Both in real life and popular mythology, the studio has functioned as a place of retreat, toil, inspiration, society and sensuality. Much of the myth-making has been down to artists: Gustave Courbet's *The Painter's Studio* (1855) imagines the artist as a languid demiurge at the heart of his atelier, surrounded by admiring hangers-on and lovingly attended to by a nude model. Andy Warhol engineered a similar combination of loitering and hero worship in his Factory, the hip hangout and produc-tion line that he presided over, in various locations in Manhattan, between 1962 and the mid-1980s. Henri Fantin-Latour's *A Studio at Les Batignolles* (1870) meanwhile imagines the studio as a crucible of gentlemanly chatter and polite critique — the atelier becomes a conduit between the artist and his community. Philip Guston's painting *The Studio* (1969) strikes a more introspective note, transforming the artist into a hooded cartoon character reminiscent of a Klu Klux Klan member — clownish, clumsy and vaguely sinister — daubing his own portrait. The studio is a rose-coloured cocoon, imaginative as much as spatial.

Away from these instances of the studio as self-portrait, all tinged with degrees of narcissism, the studio represents — for artists in the 'here and now' — an urgent necessity. Today's artists may be becoming more mobile, adaptable and unrooted — for some, the rise of digital media has eradicated the need for a permanent, dedicated place of work — but most continue to regard their studio as crucial to their practice (it is not for nothing that art-making is commonly paraphrased as 'studio practice'). Cheap studio space may be a dwin-dling resource — forcing artists today into new and unlikely habitats, from Detroit to Southend on Sea — and rents frequently outstrip incomes. Yet the studio retains a vital role in the life of an artist, and finding a studio after art school is still a rite of passage.

Lynda Benglis
b.1941

It was important to take note of Virginia Woolf — find a room of your own. I think all artists need to heed that. It becomes your outer shell.

The first studio I had was on Pixley Street in Wapping. It's always a case of someone knows someone who knows that there's a space going for forty quid a week — or maybe it was forty quid a month — in bleak wasteland buildings in areas that no one would willingly want to go to work in, because there's nowhere even to buy a pint of milk.

Fiona Rae
b.1963

Andy Warhol
1928–1987

In the years after I'd decided to be a loner, I got more and more popular and found myself with more and more friends. Professionally I was doing well. I had my own studio and a few people working for me, and an arrangement evolved where they actually lived at my work studio. In those days everything was loose, flexible. The people in the studio were there night and day. Friends of friends. *1*

I shared a space in the '80s with a group of friends from the Studio School. We were like a family. You had a day job or whatever, and then you did your thing at the studio. I got an incredible studio right near where I live in Brooklyn. This was back when you could get spaces for practically nothing. I had what they called the dancehall. But you couldn't persuade anybody to come over. It was very edgy. If they did come, you had to lock the door when they arrived, because you knew they'd want to leave right away — they were afraid to come to the area.

Joyce Pensato
b.1941

Andy Warhol

I want to live in a studio. In one room. That's what I've always wanted — not have anything — to be able to get rid of all my junk — maybe put everything on microfilm or holographic wafers — and just move into one room. *2*

The first studio I had in New York, with John Wesley, was where *Pull My Daisy* [1959] was shot — a building on Fourth Avenue. We knew somebody from California who had it, and because they had an older child, they wanted to move into a modern place across the street, so they sold it to us. It was small and all, but we were there for a year or two, and then moved into another studio next door to [Donald] Judd.

Jo Baer
b.1929

II

Breaking out

51

'Take note of Virginia Woolf — find a room of your own'

Lynda Benglis

Ian Hamilton Finlay
1925–2006

My first job was working in a commercial art studio — I was the 'boy' who got the clean water for the artists. Later, I worked in advertising for a year, as a copywriter, and learned something about brevity. *3*

I used to paint in my mum's upstairs bedroom, until six years ago.

Billy Childish
b.1959

Nick Goss
b.1981

London is an inspiring and thrilling city to work in, but more and more the only possible studios to inhabit are on the outskirts of the city. As an artist I want to be in the mix of a city — feel connected to the streets and feed off that energy. It is getting progressively harder.

I had a job in community education in the east end of Glasgow, and through that a studio was given to me. It was the top floor of the office of the community education department at the City Council. They said: 'You're an artist — you can use the upstairs space if you want. Nobody's there.' I made my first sculptures up there. There was a jobseekers' club on the other floor. The jobseekers were basically ne'er do well types who would come in and vandalize my work.

David Shrigley
b.1968

'I had various studios, all the size of a shoe box'
Rachel Howard

Joyce Pensato

I had that studio for 30 years. A couple of years ago they threw me out... the whole real estate thing.

My boyfriend at the time, Stephen Park, was at the Slade with Rachel Whiteread, and she was in a building — the Acme building in Stratford [east London] — where she put a note up for me and Steve, and so we got a studio there. It all happened like that — sublets leading to tenancies.

Fiona Rae

Rachel Howard
b.1969

I had various studios at different times, all the size of a shoe box, in Brixton, Vauxhall and Deptford, and tried to get there as much as possible. I remember it was frustrating finding time to get there, the juggle of earning money to pay for paint and a studio, and having the head space to make my own paintings. I did it for four years. It was never going to be permanent.

I USED TO PAINT IN MY MUM'S FRONT ROOM UNTIL SIX YEARS AGO.

Billy Childish

'You need discipline to create freedom'

Raphael Gygax

The combination of a free education at the Royal Academy for three years and being awarded a free studio for a year afterwards, meant that I was fortunate enough to save some money and have the time to find a suitable studio. I had decided that after art school, my work would need to take priority over my comfort and lifestyle. For a long time I had looked for an industrial unit to buy and finally found one in south London, and took out a large loan from the bank to finance it. When I first moved into it, there were very few artists or studios nearby, but due to the abundance of commercial property in the area and the shortage of studios in London, it wasn't long until there were lots of artists and makers nearby.

Charlie Billingham
b.1984

Jenny Saville
b.1970

We had this big old house, and in a corridor downstairs, there was this weird cupboard. I kept nosying around it, and eventually my mother gave it to me: it became my first studio, and no one else was allowed in. *4*

In the same way that if you read a book what really happens takes place in a kind of no space, sort of in the atmosphere. I work very much in that way, it is not centred on a particular place or on sitting in a room with a certain amount of space and thinking 'what am I going to do?' *5*

Sarah Lucas
b.1962

Raphael Gygax
b.1980

With very few exceptions I think it's really important for a young (and older) artist to create the space to nourish and evolve their artistic practice. I think reading a book, seeing exhibitions, writing a statement, or thinking about strategies can be as much a part of 'studio practice' as actually realizing an artwork. So actually, 'active' studio time doesn't necessarily happen in the studio but comes through 'awareness'. So the question is how to finance that, when there is still little or no income from the art itself. The simple and not very romantic answer is to get a part-time job. Of course it's best if that job relates to the artist's world, for example working in a gallery, or something that relates to their artistic interests. It sounds like a paradox but you need discipline to create freedom. Especially at the beginning.

Getting noticed

Supportive teachers, eyecatching degree shows, Instagram, prizes, controversy, private views, parties, self-prostitution — there are many ways of getting noticed. Original and thought-provoking work remains the safest bet for achieving success, but finding an audience of influential types is rarely easy for the young or unknown artist. For every brilliant artist who gets 'discovered' — grasping hold of commercial success and curatorial favour (if only to lose it a moment later) — hundreds graft away in relative obscurity. It was ever thus: the life of Vincent van Gogh has become a tragic cliché of the overlooked artist, and figures as canonical as Paul Cézanne and Auguste Rodin suffered severe and debilitating rejection well into their careers.

In the last 40 years, the old channels of recognition have dissolved and disappeared into a wider pool of 'opportunity' in which success can seem simultaneously ubiquitous and elusive. Artists have resorted to an array of DIY measures — dialling up dealers, clubbing together to put on shows, asking favours from friends, or even (in Damien Hirst's case) cribbing the contacts book of the gallery where he was working as a part-time technician. At the same time, many argue that their lack of careerism — a commitment to ideas rather than a pursuit of attention — was the catalyst for their success.

'Young artists should not follow any obvious trends'

Thaddaeus Ropac

On the hustle ↓

Luc Tuymans
b.1958

You should make yourself as recognizable as possible, not in terms of branding, but in terms of being sharp.

Since nobody is going to go out of their way to help you, you need to think about your best resources. Friendship and elementary social grace seemed to me to be your best friends, and if you meet enough people who mirror that, you already have critical mass. The word 'critical' is important, but not when used programmatically or for pompous effect. Getting things done is hard enough and knowing enough life craft skills to cut corners will allow you to take the bends with flair.

Richard Wentworth
b.1947

Mary Reid Kelley
b.1979

Be present with people when you meet them, and recognize and accept what they wish to give you, rather than trying to extract what you think you should get. Also, apply to everything (grants, residencies, fellowships) you think you are remotely qualified for. Even an unsuccessful application will be seen and discussed.

I've never, ever followed any career trajectory, or hung out with people, or used them to my advantage.

Billy Childish

Lynda Benglis

Follow your feelings and your intuition and structure them within particular contexts. Think clearly — that's it! *6*

Most important for an artist is to find his or her own language, trying to be informed as much as possible and at the same time influenced as little as possible. Young artists should not follow any obvious trends.

Thaddaeus Ropac
b.1960

Luc Tuymans

I would advise young artists today not to become artists just to make money, or just to be successful. I would advise that they create meaning, which in the long run is something that will persist — and the most fascinating part.

In my early twenties, I didn't really worry too much about having a career. At home in my shared flat, I made black-and-white drawings. That led me to publishing my own books, as a publicity vehicle. I'd send them to *Private Eye* and usually get a proforma rejection letter. But that led me on to making the work that I subsequently became successful for doing.

David Shrigley

Mary Reid Kelley I would never 'pitch' an art critic or journalist. They have their own creative and intellectual agendas, as much as artists do.

Pete [Doig] did introduce me to people. I went to his first show. I went Billy Childish
to 'Minky Manky' [1995, held at the South London Gallery] and had
some ridiculous conversations with Hirst and the Morecambe and
Wise pair — Gilbert & George — you know, just silly conversations. And I was invited to the
parties. I would always say to people: 'I don't do art, I make pictures.' That would really piss
them off.

'There's a whole infra-structure of different things that can make young artists visible'
Mark Wallinger

David Shrigley In the early '90s, I got a commission from Book Works — they've
been going for a long time — who publish artists' books in London.
It was the first book that was published by somebody other than me.
Michael Bracewell was the editor. He then wrote something about me in *frieze* magazine:
I was on the cover in October 1995. And that was it, basically — I was on the cover of *frieze*,
much to the chagrin of Jonathan [Monk]. I had been fast-tracked.

I used to play in little punk rock groups — we had no agent and no Billy Childish
ambition. And I used to do exhibitions in cooperatives in Germany.
But then I was on the cover of *Artscribe* for some strange reason,
in the early '90s, which Tracey [Emin] was going crazy about, and
people would give their right teeth for. I wasn't vaguely interested.
I took no notice.

Mark Wallinger Back in the 1980s, the only incentives or outlets for people like me
b.1959 were the John Moores Painting Prize, every two years, and the
 Whitechapel Open, and that was it. Now there's a whole infrastructure
of different things that can help make young artists visible. But by the same token, trying to
find an affordable space is probably the hardest thing that's facing young artists today.

I wasn't thinking about owning a house or a car or having a family. David Shrigley
I guess one doesn't, when you're 24 or 25.

Jo Baer The first paintings I did in New York were called *The Koreans* [1962]. I couldn't get them into any gallery. Nobody would touch them. Ivan Karp, a dealer from Leo Castelli, saw them and said: 'Those are the most aggressive paintings I've ever seen, and I can't imagine anyone ever buying one.' I was going to burn them and Dan Flavin, who was a friend, said, 'No, I'll take them.' He didn't take them in, actually — I stored them in another artist's studio and had to pay rent on them. They weren't shown until 1972.

Submitting work for exhibitions must still be the best way of getting noticed. New Contemporaries and the RA Summer Show, for example, are opportunities for showing one's work in a professional environment and a place for talent scouts. The discipline of filling in forms, framing, paying submission fees and the hopefully occasional rejection is all part of the toughening-up process.

Allen Jones
b.1937

'I never thought of having a career, therefore I got one'
Luc Tuymans

Thaddaeus Ropac I still believe very much in the old-fashioned way of sending portfolios. We look very carefully at everything that is sent to us, often as a team. We talk a lot to critics and curators who point artists out. Many galleries watch young artists very carefully and accurately, so artists shouldn't need to make their art known in a spectacular way.

I've never approached anyone. Tracey [Emin], when she was at Maidstone, tried to organize a couple of exhibitions for me, and some poetry readings. A girlfriend in the mid-1980s tried to get some money for me: she sent out flyers and I did get an exhibition at a bank in Belgium called Spar Credit. Very strangely — I only remembered this a couple of years ago — I got four hundred quid off the Pollock-Krasner Foundation, because she'd sent them some slides of my pictures, and they gave money to people to buy materials. It's really funny, because I've often complained about [Jackson] Pollock, and not really looked at [Lee] Krasner, although my friends tell me she's got a lot more substance than Pollock. But that was by proxy, if you will.

Billy Childish

Luc Tuymans I never thought of having a career, therefore I got one.

IF YOU SAY YES TO SOMETHING, SOMETHING ELSE MAY HAPPEN. BUT IF YOU SAY NO, YOU KNOW IT WON'T HAPPEN.

Fiona Rae

It's essential for artists to be able to say two or three coherent **Raphael Gygax**
sentences about their work. The language can be really simple.
No need for vocabulary that you don't understand. Seriously, never
use words and terms that you don't understand. In short, I think it's
empowering to lay some of the fundamental foundations yourself
rather than let someone else do it.

Billy Childish I only had a break as a painter when I was 50.

As a curator I'm very hesitant about doing 'studio visits', as they always **Raphael Gygax**
raise expectations and put both parties under a lot of pressure. So I'm
not sure if it's the best strategy to send around invitations to curators
for studio visits. I think this is kind of humiliating. I always recommend to my students that
they create 'communities' with their friends, with like-minded people, establish a space,
start a discourse. Don't wait like a 'helpless victim' for someone to reach out to you, as this
most probably will never happen. You need to empower yourself! It sounds all really easy;
and I know it's not. It needs energy. But the good news is: this community will not only
become your security blanket but also your first audience. And from that you might build —
at some point curators come by themselves. Most of them are curious little animals who can
sense energy. At least some of them.

Self-determination ↓

Tess Jaray There is something very special about young art. It's a time when
b.1937 would-be artists are most open to new ideas, to the world, when every-
thing seems possible. Young art has a very special quality, I see it almost
as a movement in itself. And perhaps the best artists are those that
never quite lose that, but it's rare.

It was in the early '90s when the realization came: what was I doing? **Joyce Pensato**
My father had died. I found myself doing a job that I complained about,
for three or four days a week, and seeing a lot of friends getting shows.
And I thought: I have to give myself some time.

David Shrigley It was a small scene in Glasgow at that time: everybody knew every-
body and it was just a place to be. You had housing benefit and
a part-time job, and you were able to do your thing.

'Figurative painting was how to make a living'
David Shrigley

At art school, we set up this thing called the Slade Engine, which was a collaboration between our year at the Ruskin and the Slade. We put on shows at a dozen warehouses and got as many people as possible to come and see them. We worked as a kind of collective, although we were still autonomous artists. We did all the advertising and printed the postcards. It was a really good way of mobilizing ourselves. From that, I got into New Contemporaries.

Conrad Shawcross b.1977

David Shrigley

When I graduated, I didn't think that it was possible for people of my generation to be professional artists. I thought that in order to have a career as a fine artist, the only thing was to be a figurative painter. That was the example that had been set by artists like Stephen Campbell and Adrian Wiszniewski. Figurative painting was how to make a living.

Damien [Hirst]'s idea to do 'Freeze' in 1988 was manna from heaven — something I could work towards. In those days no one went looking to see what a bunch of recently graduated kids were doing. No one cared. Why would they? So there was a DIY motivation. There was a lot of work preparing the building, and lots of tension and squabbling because we were a bunch of art students.

Fiona Rae

David Shrigley

I was learning to play the guitar and was then in bands and stuff, I had other things that I wanted to do. But I was still focused on making drawings.

'No one cared what a bunch of recently graduated kids were doing'
Fiona Rae

Part of me thought: 'Oh it's pointless, no one will come, what's the point?' But then I also thought: 'It's an opportunity: who knows? Let's just do it!'

Fiona Rae

Rachel Howard

I was asked by another artist to be in a group show. This was a tipping point. So I packed up my paintbrushes for Damien [Hirst] and at 25 started showing my paintings. I'm fully aware that things are much tougher in so many ways for graduates now: the uncertain political and economic landscape, the simple fact that studio spaces in London now are so scarce, student loans, etc. But these are the realities for all art students leaving college.

I WOULD SAY TO PEOPLE 'I DON'T DO ART, I MAKE PICTURES.' THAT WOULD REALLY PISS THEM OFF.

Billy Childish

'The head is only needed to calibrate the heart'

Tess Jaray

Fiona Rae

One of the things I've learnt over the years is that if you actually say yes to something and do it, something else might happen. But if you say no, you know it won't happen.

David Shrigley

There weren't really any resources in Glasgow in the early '90s. There weren't any commercial galleries, for example, and only one or two spaces that were interesting — CCA, Tramway... It wasn't as if there were curators or gallerists you were trying to ingratiate yourself with. All the curators — all the 'important folk' — were people who were coming to visit. Perhaps there was a bit of a clamour around them when they came. But for me, the inspiring thing was being around other people who wanted to make work, who wanted to be artists.

Tess Jaray

I'm probably imagining this, but I think the best advice I received early on was that old cliché: 'Be true to yourself as an artist.' Of course as a young artist you don't really understand what that means, as you are so busy trying to be like some older admired artist, and you don't know what 'yourself' is yet. But it is still essentially true, because unless you see and communicate things from your own perspective, you are still riding on others' ideas. Although the word 'ideas' is not quite right, as most visual creativity comes from the heart, not the head. The head is only needed, in my view, to calibrate the heart.

Joyce Pensato

In the '80s, after art school, I just did one or two group shows with friends. I was oblivious. I was doing my thing in Brooklyn. It was just whatever you could get on your resume, which wasn't much of anything.

James Rosenquist
1933–2017

It's so expensive in New York that the young artist thinks he or she has to show their fine art immediately and the critics say they stink and they go, 'Oh, no, I really am bad? Oh, that's terrible', and then they have to work twice as hard to show the audience that they're actually pretty good. [7]

Jo Baer

What I really wanted to do — and it's one of the things that distinguished me from most artists that I know of — was to make work that I'd never seen before. I could take parts from other artists — but I wanted to make things that I'd never seen.

Jenny Holzer
b.1950

I had my first international show after Dan Graham noticed the anonymous street posters I'd wheatpasted around New York and asked who did them. Dan recommended me to Rüdiger Schöttle in Munich, and Kasper König put me in his 'Westkunst' exhibition thereafter. [8]

First shows

An artist's first show, like the first line of a novel, can be arresting or clumsy or unremarkable. It is an opening gambit — usually a degree presentation. But it is also, for many, a decisive stage in the long process of becoming an artist; a kind of *Look at me now and here I am* moment, to borrow Gertrude Stein's staunch expression of self. A moment in which self-discovery merges with the excitement and anxiety of 'being discovered'. Many artists, when asked about their first show, think back to the first project that mattered — the one where 'everything began' (even if it didn't seem so at the time). For this reason, the 'first show' can be a construction of the memory — a retrospective charting of one's beginnings.

My first show was my degree show. The work wasn't noticed, but it was the first time I'd felt the responsibility of working within a space. This was a significant lesson.

Ged Quinn
b.1963

'You need to open the doors to everyone'
Joyce Pensato

Joyce Pensato

I was in a summer show with Paul McCarthy in 1992. I got to meet him before he became 'Paul McCarthy'. He had a box of toys — I thought he had actually broken into my studio and taken them. That was my first taste of really being visible.

I met Tracey Emin when I was expelled from Saint Martin's and she was a fashion student at Medway. I don't hang out with artists or do parties or schmooze with anybody. But I do happen to be friends with Tracey Emin and Peter Doig. Around the time that Pete won the John Moores Prize, he was running a co-op in Cubitt Street, and he put an exhibition of mine on.

Billy Childish

Joyce Pensato

In 1990 or '91 I had a one-person show planned at Fiction/Nonfiction gallery, run by José Freire. He cancelled the show two weeks beforehand. I was shocked. I had been counting on this being my big moment. But when I think about it now, it was the wrong time. As a result of the cancellation, a lot of artist friends told people to go and see my studio. Before then, I had tried to do it all on my own, which was kind of stupid, because you need to open the doors to everyone.

Finally, Richard Bellamy gave me a show by accident. He had several galleries, and he showed [Claes] Oldenburg and [Donald] Judd and all those people. That show took me immediately on to 'Systemic Painting' at the Guggenheim [1966, curated by Lawrence Alloway], and from that minute my work was in museum shows: it was the beginning of Minimalist art. One piece was bought for the Museum of Modern Art, another for the Guggenheim. So my first work in public went immediately into museums. It's a very different story from everyone else's. And there was no one advising me — I was just doing what I was doing.

Jo Baer

Joyce Pensato

That shock of my show being cancelled made me take a look at what I was doing. That was really important. I was doing Mickey Mouse drawings, but my paintings were totally abstract — I was so divided. It made me realize: why am I forcing myself to try to do abstract paintings? Why not embrace what you love to do?

At the time, 'Freeze' [1988, Port of London Authority building] felt like | Fiona Rae
it had a huge impact. There were very nice opening nights, and we did
it as professionally as we could, and there was lots of optimism.
It was a slow build, the mythology of 'Freeze'. But from 'Freeze', Adrian Searle came and
selected me for a group show at the Serpentine. And Stuart Morgan then selected me for
'Aperto' at the Venice Biennale [1993]. So that's how it happened for me.

David Shrigley I graduated in 1991, and then in '92 I was in a group exhibition with
Martin Creed at Transmission Gallery. Come '95, I was invited to
do a solo exhibition at the Transmission Gallery. It's a little gallery,
an artist-run space, but at that time it was very important. It represented the endorsement
of my peers — because the committee were my friends, and there was only one local artist
who would do a solo exhibition every year.

The Serpentine show was very exciting. I had five big paintings in it. | Fiona Rae
But I didn't even know that you could go along and be there for the
hanging. All the other artists were there, and I just sent ten paintings
off in a van. Adrian Searle picked them and hung them. Then I turned up at the private view
and saw which ones he'd picked, which was a bit of a shock. At the time, I thought: 'No, no —
they're the wrong ones!' But they were the right ones.

'I actually think that Charles Saatchi really pisses around'
Edward Allington

Conrad
Shawcross I had a show a year after I left my MA, a solo show on Cork Street.
I was approached by a gallery. This was 'The Nervous Systems'
[2003, Entwistle Gallery], which was a big rope machine. It was bought
by Saatchi, and well received critically. So it started from there.

I actually think that Charles Saatchi really pisses around in this way: | Edward
you're doing your work, and then a rich collector comes and says: | Allington
'I'll buy all your work now.' It's hard to say no. But then, and Saatchi | 1951–2017
has done this, the collector decides he isn't bothered, and dumps
them all on the market. He did this after he bought all the Dekor artists
from the Sonnabend Gallery in New York. It destroyed the gallery
— and the artists.

IT WASN'T GOOD ENOUGH FOR NEW YORK, FOR A FIRST SHOW, OR FOR ANYTHING.

Jo Baer

AT THE TIME I THOUGHT: 'NO, NO — THEY'RE THE WRONG ONES!' BUT THEY WERE THE RIGHT ONES.

Fiona Rae

Maggi Hambling
b.1945

At the end of my National Gallery residency in 1981, Nicholas Logsdail asked me to lunch. He said: 'Well, you're doing very well — this National Gallery thing, it's all wonderful Maggi. But now you must go to Berlin.' And I said: 'I don't want to go to Berlin, I want to go back to the quiet solitude of my studio.' The last thing I wanted was to go anywhere. I wasn't going to be told to go to Berlin.

My first solo show [was] in London in 1998... I remember wondering if anyone would come, forgetting that I'd invited anyone and everyone who I met leading up to the opening. 9

Peter Liversidge
b.1973

Billy Childish

Matthew Higgs turned up working for White Columns in New York, and he said: 'Well I'll do a show with you at White Columns.' Nothing came of it for six years. And then when it happened, the ICA said to him, 'Do you think he'll do one here as well?' So from no shows, and no art world status, I suddenly had concurrent shows at the ICA and White Columns. Then Matt [Higgs] said to me: 'Oh, Tim Neuger came by the gallery because his plane was cancelled. I told him to come to the show.' And Tim said, 'Maybe I could do a show with you.' I didn't know anything about neugerriemschneider [Berlin] or any of these galleries.

'From no shows I suddenly had concurrent shows at the ICA and White Columns'
Billy Childish

Finding a gallery

Long before mega galleries, commercial galleries were instrumental in nurturing artists — from legendary Parisian dealers such as Paul Durand-Ruel and Ambroise Vollard (champions respectively of Impressionism and Modernism), to the impresarios of mid-century New York — Leo Castelli, Richard Bellamy, Peggy Guggenheim and the notoriously hard-nosed Betty Parsons. Most artists require a gallery, just as writers depend on agents and publishers. The gallery offers a platform for showing work, a commercial support, emotional crutch and general sounding board. By the same token, galleries need artists; and many are on a constant lookout for new or unsung talent. How have artists negotiated the delicate, opaque channels of preferment that lead to representation? How does the gallery fit into — and facilitate — their working life?

Galleries are part of the system. Without one you won't get where you want to be. Selling is tough. Many artists aren't great at it. It requires an endless preparedness to humiliate oneself.

Ged Quinn

'Without a gallery
you won't get where
you want to be'
Ged Quinn

Jo Baer

I moved to New York in 1960 with John Wesley, who was then my husband. He was doing some of the first Pop Art, and I was doing other things. I went around to galleries and made appointments with Leo Castelli and others. Richard Bellamy had several galleries in New York. So I made an appointment with him.

Back in the early 1990s I thought, 'I'm never going to get a gallery, no one wants me'. Then Leslie Waddington saw my work at 'Aperto' [1993, Venice Biennale] and wanted to do a show.

Fiona Rae

Jo Baer

But then, back at home, I looked at what I was doing and I cancelled all the appointments. You see, the work wasn't good enough. It wasn't good enough for New York, for a first show, or for anything. There's a photograph of me at the phone cancelling the appointments, wearing my best black dress. I was looking very pretty — good clothes on and a child in the background. Or maybe it was a cat.

I'd reached a very serious impasse, and I just took a bunch of paintings with me, and went up there, and asked if I could see [Betty Parsons]... And then I'm standing there in this small room, surrounded by these inferior creatures that I have made, and — trying to figure out whether I should just flee, or whether it would be better to just stand there in this loneliness. And before I could make up my mind, she was back and she said, 'Well what are these?' 10

Robert Rauschenberg
1925–2008

Ged Quinn

Early on the temptation is to release too much from the studio, and some galleries exploit this. I really don't know if there are ways of controlling your work's market. So I wouldn't try.

THERE IS A THING CALLED ART BASEL.

Billy Childish

Maggi Hambling I had my first show in London, at Morley Gallery, in '73. That was before being in 'British Painting' [1974, Hayward Gallery], and that's when I really came to people's attention. Jeffrey Solomons, who was a director at Fischer Fine Art, which was the big gallery back then, came to the show at Morley Gallery and stood in front of a big painting I'd done of Lett Haines. He said: 'If you do me 20 of these, we'll give you a show.' Well of course, a lot of people would have done 20. I said: 'This is this painting. I'm not going to do 19 more. What do you mean?'

David Shrigley My gallery found me: I'd had one solo exhibition and been in a couple of group shows, and then I was on the cover of *frieze*. But I hadn't really made very much art. I'd just made a few books. I'd spent half my time learning to play the guitar.

Jo Baer I found a gallery by accident. Frank Stella's wife, Barbara Rose, was doing an article on Minimalism, 'ABC Art'. (She was sort of a girlfriend of Judd's, one of the girlfriends — although I don't know if they ever got it on — and I was a neighbour). She came by and took some photographs, although when the article came out, she never mentioned me. But the picture stayed in. And because of that, somebody called Donald Droll from the Fischbach Gallery called up and gave me a show.

Conrad Shawcross Having a gallery is very important. But it's not everything: I do a lot of things outside of the gallery. I work on public commissions and other things that my gallery isn't involved in.

Jo Baer I didn't get on well with them, for a lot of reasons — I left the gallery — they wouldn't give me money. Oh, and they kept describing my paintings as 'fields of snow' and things like that, which was ridiculous.

Thaddaeus Ropac The gallery has the crucial role of being the intermediary between the artist, studio and broader audience — which includes collectors, curators and critics. Artists should concentrate on their art, and not on showing, promoting and placing their works. Without a gallery, artists cannot devote themselves entirely to their work.

'Without a gallery,
artists cannot devote
themselves entirely
to their work'
Thaddaeus Ropac

'Be sure to feel a connection to the gallery programme'
Raphael Gygax

Billy Childish Tim Neuger said to me: 'There's a thing called Art Basel,' — which I'd never, ever heard of — 'and we're going to do a solo show with you at Art Basel.' So I went to Art Basel — I'd never hung out at these things. I turned up there and there was a TV crew and everyone was going bonkers about my exhibition because it had sold out on the first day. There was lots of interest in what I was doing, and that's how Lehmann Maupin — Rachel Lehmann — saw my work (she said she'd never heard of me) and asked if she could represent me.

In '94 I went from not having any one-person shows to having three **Joyce Pensato** one-person shows, all in France. Then I came back to New York and I went with Max Protetch Gallery. That's where I had my first show in New York. He had a lot of great artists but he couldn't hold on to them. And he wasn't into my work totally, so I left him in '97. I thought I could do better. I knew lots of people, and I was hoping to find another gallery, but wasn't so good at that. Mostly I went back to Paris — that's where I seemed to find more support.

Larry Poons Galleries — it reminds me of the legal term, 'for any or no reason'.
b.1937 It's true. You know, there's a club in this country, the Sports Car Club of America, and in their handbook, they write: 'We can kick you out of our organization for any or no reason.' I figured that's a wonderful term. And I figured there are always a lot of lawyers in the ranks of the Sports Car Club who would have a gripe with the authorities. So the authorities got sick and tired of dealing with all these smart lawyers, and said: 'Look, we can kick you out for no reason — goodbye! If you don't agree, you don't have to sign up and give us money.'

Galleries are growing bigger and bigger and bigger, and are like mono- **Luc Tuymans** liths in the landscape. It's very dangerous in a way. It is not that simple to become an artist right now. In my day it was far simpler. That's the only thing I can say. Because all this ballast, and all these problems which are largely market-related, were not that immediate then.

Raphael Gygax Whether you need a gallery depends what kind of work you're doing — an artist who works mostly in the field of so-called artistic research doesn't necessarily need a commercial gallery, and has to fight in a very different battleground — namely academia. For an artist who works mainly as an 'exhibition artist' — the paradigmatic model of the modern age — it's very helpful to have a gallery. But it's really important to be aware that the 'gallery market' is as pluralist as the art market. And it's a delusion to think that one of the ten global players should be the end goal. Check out the gallery programme, be sure to feel a connection to the programme: sympathies play a big part, but it's also never wrong to check a gallerist's reputation.

GALLERIES — IT REMINDS ME OF THE LEGAL TERM 'FOR ANY OR NO REASON'.

Larry Poons

Notes

1 Andy Warhol, *The Philosophy of Andy Warhol: From A to B and Back Again* (New York: Harcourt, 1975), 24 *2* Ibid., 196 *3* Ian Hamilton Finlay, quoted in James Campbell, 'Avant Gardener', *The Guardian*, 31 May 2003, 22 *4* Jenny Saville, quoted in Rachel Cooke, 'Jenny Saville: "I Want to Be a Painter of Modern Life, and Modern Bodies"', *The Guardian*, 9 June 2012 *5* Sarah Lucas, quoted in Brigitte Kölle, 'You Can't Hide Behind a Cloud all the Time: Brigitte Kölle in Conversation with Sarah Lucas', in Brigitte Kölle (ed.), *Sarah Lucas*, exh. cat. (Frankfurt am Main: Portikus, 1996) *6* Lynda Benglis, quoted in Micah Hauser, 'An Interview with Lynda Benglis, "Heir to Pollock," on Process, Travel and Not Listening to What Other People Say', *Huffington Post*, 25 March 2015 *7* James Rosenquist in interview with Jane Kinsman, Florida, May 2006 (National Gallery of Australia website: www.nga.gov.au/Rosenquist/Transcripts.cfm) *8* Jenny Holzer, quoted in Rain Emuscado, '10 Influential Artists Recall their First Exhibitions', Artnet, 11 August 2016 *9* Peter Liversidge, quoted in Emuscado, '10 Influential Artists Recall their First Exhibitions' *10* Robert Rauschenberg in interview with Barbaralee Diamonstein-Spielvogel, 'Inside New York's Art World', 1977, Diamonstein-Spielvogel Video Archive

III On the scene

The artists, two art historians, a curator^Δ and a dealer^Ω ↓*

Edward Allington	Carl Andre
Jo Baer	Lynda Benglis
Billy Childish	Joseph Cornell
Jesse Darling	^Δ Raphael Gygax
Ian Hamilton Finlay	Damien Hirst
Howard Hodgkin	Rachel Howard
Tess Jaray	Derek Jarman
Sarah Lucas	Grayson Perry
* Pliny the Elder	Jackson Pollock
Larry Poons	Ged Quinn
Fiona Rae	^Ω Thaddaeus Ropac
Dante Gabriel Rossetti	Conrad Shawcross
David Shrigley	* Giorgio Vasari
Mark Wallinger	Lawrence Weiner
Richard Wentworth	Issy Wood
Christopher Wool	

Generation

On the scene

Ante generation system **Born before 1883**	*11 ↓* Diodorus Siculus Marsden Hartley Winslow Homer Immanuel Kant Leonardo da Vinci	Pablo Picasso Pliny the Elder Auguste Rodin Dante Gabriel Rossetti Giorgio Vasari Oscar Wilde
GI Generation **1900–24**	*8 ↓* Francis Bacon Louise Bourgeois Joseph Cornell Salvador Dalí	Willem de Kooning Alberto Giacometti Philip Guston Jackson Pollock
Baby Boomer **1945–64**	*19 ↓* Edward Allington Billy Childish Tracey Emin Eric Fischl Maggi Hambling Jenny Holzer Anish Kapoor Jeff Koons Michael Landy Sarah Lucas	Philippe Parreno Grayson Perry Ged Quinn Fiona Rae Thaddaeus Ropac Luc Tuymans Mark Wallinger Richard Wentworth Christopher Wool
Millennials **1980–2000**	*5 ↓* Charlie Billingham Jesse Darling Nick Goss Raphael Gygax Issy Wood	

Lost Generation
1883–1900

1↓
Marcel Duchamp

Silent Generation
1925–44

24↓

Carl Andre	Tess Jaray	Dieter Roth
Jo Baer	Derek Jarman	Richard Serra
Phyllida Barlow	Allen Jones	Andy Warhol
Lynda Benglis	Gustav Metzger	Lawrence Weiner
Michael Craig-Martin	Bruce Nauman	
Helen Frankenthaler	Yoko Ono	
Gilbert & George	Joyce Pensato	
Ian Hamilton Finlay	Larry Poons	
David Hockney	Robert Rauschenberg	
Howard Hodgkin	James Rosenquist	

Generation X
1965–79

8↓

Damien Hirst	Mary Reid Kelley
Chantal Joffe	Jenny Saville
Peter Liversidge	Conrad Shawcross
Chris Ofili	David Shrigley

The art world

'The Artworld', wrote the philosopher Arthur Danto, 'stands to the real world in something like the relationship in which the City of God stands to the Earthly City.' For some artists, these two realms blur into a single reality: the art world is a vital environment, an arena for exhibiting, selling and socializing. It is the social and cultural crucible within which artists define themselves, and provides a frame for understanding what art is or might be. But the art scene (perhaps a different thing) can feel less than real — a whirring carousel of glittering events and egos, in which artists are crowded out by curators, dealers, critics, advisors and collectors.

The French painter Henri Fantin-Latour chose increasingly to retreat to the Louvre and his own studio, writing in 1875 to the German painter Otto Scholderer: 'You're right about Artist gatherings; nothing measures up to one's interior.' Few artists nowadays have the same luxury. But how far should they participate in, or resist, the social whirlwind of parties, private views, auctions, art fairs and biennials? Can the art world — wherever it happens to be — be exploited and enjoyed? Do artists even consider themselves members of that world, or do they feel themselves to be looking in from the edges?

On the scene

II

'There's an audience for contemporary art that wasn't there 20 years ago'

Mark Wallinger

Lynda Benglis
b.1941

The art world is always forming and reforming, and dying — because people die. You can't force yourself on the situation, you grow with it. The 'art world' as such is meaningless to me. You grow with the people that you're attracted to.

Jesse Darling
b.1981

Art is just the name for a set of compulsions and neuroses, or otherwise devotional or ecstatic practices, or gestures of mediumship in between God and the world. In the current denomination it's the 'art world' that functions as the container to legitimize these rituals.

Conrad Shawcross
b.1977

This idea of the art world or the art scene — it's subjective to everyone. It doesn't exist as a real entity, as a real thing. I certainly hang out with people from the art world, people who are artists and who work within the art industry. But there are many overlapping worlds. Of course I'm involved in it, but I'm not out at shows every night and networking all the time. I'm mainly in the studio — I live above the studio, and a lot of people come and see me here.

Grayson Perry
b.1960

When I left art college in 1982 art felt like a messy amateur business of academics, poshos and enthusiasts — a cultural ghetto of awkward bohemians doing inexplicable things. 1

Edward Allington
1951–2017

I think there was a cultural shift in the 1980s. I think that for my generation, in the 1980s, and particularly the generation before us, it was hard. The art world was smaller. Then in the 1990s it got bigger. There were a lot of very strong artists around before my 'group' came up (it wasn't a group, exactly, but it damaged them). Then when the YBAs turned up, it damaged some of us — but hey, that's what happens.

Larry Poons
b.1937

The art world is as broad a term as you want to make it. The industry of art always existed. It's mainly an industry to make money, to support oneself.

Mark Wallinger
b.1959

When people talk about the art world I never quite know what it means, and it doesn't really enter my head on a day-to-day basis. Obviously things have changed a great deal: we've got Frieze and all these other art fairs, and probably a dearth of alternative spaces of the kind that started flourishing about 20 years ago. But at the same time there's an audience and an appetite for contemporary art that wasn't there 20 or 30 years ago, or not to the same degree.

But there are many art worlds, some of which sustain themselves perfectly well outside the spectacle-industrial value-creation complex that plays out in a parochial network strung between a few globalized nodes of unequal affluence. And there are millions of artists both now and throughout history who have made their work without recourse to these value creation networks, but then again, it's hard to know who and where they are if there's no distribution system.

Jesse Darling

Ged Quinn
b.1963

It is possible to be an artist without embracing the art world. But you might not have a choice — it may embrace you.

The California scene in the 1950s centred on Ferus Gallery and places like that, it was a very particular thing. It was mostly about Man Ray. Buddyfuck was what it was called. It was all men. I hung out with them, they knew about me, but I wasn't showing with any of them. So I learned the art world in Los Angeles, before going to New York.

Jo Baer
b.1929

Sarah Lucas
b.1962

Funny thing was, around that time, back in '89–90, blokes I knew were being courted by blokes with galleries. Simon Salama-Caro, Nicholas Logsdail, Anthony d'Offay, Karsten Schubert. I must have been quite jealous. And quite angry. Like getting stuffed with the baby, and other sudden realizations about the inherent inequality of things. Not that I was angry all the time — mostly it emerged after 13 bottles of Holsten Pils, about once a week. 2

I went to three Britart exhibitions, but I didn't drink, I didn't smoke, I've never done drugs. I'd been alcoholic until about that time. I was not interested in hanging out with any of them.

Billy Childish
b.1959

'It is possible to be an artist without embracing the art world'
Ged Quinn

YOU DON'T LIKE EVERYTHING, NO ONE DOES. EXCEPT MAYBE IN A BUDDHIST SENSE.

Larry Poons

Jo Baer

There were a couple of years when I couldn't even get anyone to look at the work, because my husband was becoming a big Pop artist. They wouldn't even speak to me. People we knew would invite him to openings, and not me. I suppose it's because I was female.

I remember in about 1989, when I was still an outsider and all my mates were having shows and I wasn't, and it really bugged me. As I was making the fly piece, I was thinking: 'I'm gonna show you. I'm gonna kill you with this one, knock you down dead, and change the world.' And I showed it to a few galleries and they all just turned round and went 'Marvellous, darling.' It didn't have the effect I wanted. It had the opposite effect. I was gutted, in a way. *3*

Damien Hirst
b.1965

Tess Jaray
b.1937

The art scene is turned inwards, with its unavoidable commerce and its competitiveness and jealousies. It has to be like that to concentrate on what is important to it. And of course artists cannot really do without it. But an artist surely has to be a person first, someone who can stand back and see what it means to be human, as well as someone who can focus on things so fine that they can't be seen with the naked eye.

I go to a few art fairs — only those within easy reach. Auctions never. Artists should probably not go to either. It is a market place after all — but an art fair is an efficient way of checking the weather, like a magazine.

Ged Quinn

On the scene

≡

'I can play the game, but I don't really fit'

Damien Hirst

Jo Baer

That's the real reason I moved to Ireland — to get away from the art world. I didn't take much part in the art world. Visitors would come and say, 'Why don't you start making the old work again?' That was because it was so saleable.

Scotland has never been kind to me. I don't know why… I feel on the edge as regards the Scottish scene, but as regards the world I feel in the centre. I seem on the edge because I'm in the centre. *4*

Ian Hamilton Finlay
1925–2006

Damien Hirst

I can play the game, but I don't really fit. *5*

'It's important to socialize with other artists'

Rachel Howard

There are only a few artists who actually want to go to art fairs. The majority of people are sensible and find it incredibly tedious. I go when I'm summoned, but I would never go otherwise.

David Shrigley
b.1968

Thaddaeus Ropac
b.1960

It is sometimes useful [for artists to embrace the art world], but it's a possibility rather than a necessity. Some artists embrace it, but it has to be natural. Any serious gallery would accept the personality of their artist and help them according to their own abilities and wishes.

I wouldn't dream of going to an auction of my own work. That would be like going to your own funeral. I don't think any artist would do that unless they were totally mad. I mean, it's just not a nice thing to see.

Conrad Shawcross

Art fairs I go to if I have to set something up, but not otherwise. It's quite a limiting way to see works of art. Art fairs bring out the more base sides of artistic egos and competitiveness and self-loathing. They don't really inspire idealism.

Jo Baer

What is happening to the art world, all over, is that academics have turned into curators. The power people are ruining it — putting all their friends in, with their own ideas. Painters, when they do very good work, do not do what academics want. Please remember that. They've taken over everything, the art fairs and everything else.

Sometimes you might go to Frieze just for social reasons, just because it isn't too far away. But the art world en masse is quite tedious. Unless you happen to have £15,000 (or £50,000) to spend, you wouldn't want to go to an art fair. Ultimately they're not an artist's place. You feel like a factory worker who's appeared in the shop — you don't belong there.

David Shrigley

Billy Childish

I went along to Pete Doig's solo show at the Whitechapel Gallery [1991] and he introduced me to some of our old tutors. They said, 'We don't remember you.' I said, 'That's because I wasn't there very often — I was expelled.' One tutor said, 'Why was that?' I said, 'Because I'm a drunk.' And then they looked very taken aback. I said to Pete, 'Do you think I should leave?' And Pete said, 'Best to.'

If you spend your time in the right place, i.e. in the studio, then the rest follows. But you shouldn't lock yourself away, especially if you're a painter. It can be unhealthy mentally. It's important to socialize with other artists. They can be very forthright about each other's work, and a good critique of one another's work can be very productive.

Rachel Howard
b.1969

THE ART WORLD IS ALWAYS FORMING AND REFORMING, AND DYING — BECAUSE PEOPLE DIE.

Lynda Benglis

Howard Hodgkin
1932–2017

It's a very lonely occupation being a painter; I wouldn't recommend it to anybody. *6*

'If you're scared to do it alone, go with a friend. You need friends!'

Raphael Gygax

Because success only happened when I was 50, I'm always suspecting that the art world will equally just decide that they don't like what I do. Well, if they do, I'll just cut my cloth accordingly. I'm a natural creative type — I don't meet many people like me — and I don't meet many people like that in the art world. And I don't hang out with them.

Billy Childish

Tess Jaray It is life itself, not the 'art world', that is the springboard for the work.

It's inevitable that you know your context — and if you're heading towards an artistic career that generates income from the art market, then it might be quite useful to check that context out.
I would never say that you have to 'embrace' it. But you do need to know your peers in the art world, and it's always better to talk about something that you have seen in real life, and experienced. And eventually you might also find friends. If you're scared to do it alone, go with a friend. You need friends! If you have a social phobia then go and see shows during normal opening hours.

Raphael Gygax
b.1980

Friendships, rivalries, fallings out

Artists can be solitary and individualistic types. This may be why artistic friendships are so intense, and their endings so rancorous. The story of great art has repeatedly been a story of friendship and rivalry: Zeuxis and Parrhasius; Brunelleschi and Donatello; Picasso and Matisse; Freud and Bacon. Creativity has thrived on companionship or discord, or a strange compound of the two. Lucian Freud once said of Francis Bacon: 'His work impressed me, but his personality affected me' — friendships are hard to separate from rivalries or enmities.

Beyond individual friendships, artists have tended to pool into close circles. These might be rarefied (the Bloomsbury set) or brash and Rabelaisian (the Young British Artists) — or both. Most artistic cliques are characterized by mutual support, collaboration, jealousy and shifting sexual alignments. Some groups are organized and carry manifestos, while others are unintended and incidental. The Impressionists, for instance, were so-named in a scathing review by the art critic Louis Leroy.

Then there are the renegades and recluses, artists for whom society itself is a kind of sparring partner. Caravaggio, a lifelong outsider, killed a rival — supposedly in a botched castration attempt — and went on the run. For many, seclusion has been less scandalous in its motives but no less determined and life-defining. Ian Hamilton Finlay, the Scottish artist and poet, was afflicted by severe agoraphobia: he remained for years at a time in the rural Pentland Hills, in his garden colony, Little Sparta. Joseph Cornell's crippling shyness restricted him to just a few close alliances. But even for those artists who renounce society — perhaps particularly for them — friendship remains vital.

Pliny the Elder
23–79 AD

Scopas's rivals and contemporaries were Bryaxis, Timotheus and Leochares, who I must discuss alongside him because they all worked on the relief sculptures of the Mausoleum [of Mausolus, ruler of Caria]. These sculptors made the Mausoleum one of the Seven Wonders of the World.

I remember being taught that if artists don't get on among themselves, then they can't expect audiences to get on with them.

Ged Quinn

Fiona Rae
b.1963

We all went to each other's shows. It was a scene. It was so much smaller than now — you would hear that someone had a show at City Racing down in south London, or at the Chisenhale [Gallery, E3] — and you'd just turn up and then go to the pub. But you can't keep doing it. I could never be a massive party person because I had to be up the next day. I couldn't order my work over the phone.

I always said, back in the day, that I was Establishment. The Brit artists wanted to be the outsiders, but they weren't. I'd have happily exchanged places — because I consider myself very Establishment.

Billy Childish

Ged Quinn

Whether you choose to share a studio — or home — with other artists depends which point you are at in your development. You might find a good situation with a febrile energy that pushes you further than you might without. I'm happy working alone.

'I consider myself very Establishment'
Billy Childish

Does the art world even want to be embraced?! I think there's camaraderie between artists with mutual anxiety or nausea around what goes on commercially and socially at openings and fairs and dinners. Does an artist belong at any of these events? Or should we have just stayed late in the studio?

Issy Wood
b.1993

Jackson Pollock
1912–1956

People have always frightened and bored me, consequently I have been within my own shell and have not accomplished anything materially. [7]

You know, I was thinking, I wish I hadn't been so reserved. [8]

Joseph Cornell
1903–1972

Rachel Howard

It is usually other artists who have introduced my work to other people, as I do too with artists whose work I admire.

'It's your job to spot stimuli'
Richard Wentworth

You wish each other well and at the same time go, 'Oh no, what about me?' But actually there was a lot of generosity, particularly with Damien [Hirst]. He would send people to the studio. And if someone was doing the rounds, one of us would say, 'Oh, you should go and see so-and-so as well.'

Fiona Rae

Richard Wentworth
b.1947

Anybody who encourages your mentality is important. The 'cour' in encouragement is the word for 'heart'. Any stimulus stands a chance of helping you discriminate and develop. It's your job to spot stimuli.

At the New York Studio School in 1973, I met Christopher Wool. He was about 18 years old, and I was a little older, and we shared a studio. He has been a major part of my life. I got to share his family — we both adopted each other. I called us the Woolies. His dad was my first collector, because Chris brought him in to see my drawings. They were Batman drawings.

Joyce Pensato
b.1941

Carl Andre
b.1935

I didn't like men, but I liked women. I had a few close male friends, like Michael [Fried] and Hollis [Frampton], but in general I didn't like men because they were so physically competitive. Men are always making a pecking order. 'I can beat you up and you can beat him up…' You can always find somebody to beat up. This goes back to the schoolyard. *9*

I had a studio, a room of my own, so I could invite artists around. The first artist I invited to my studio happened to be Carl Andre. I went to his first exhibition: the elevator opened and he was sitting in his overalls on a big piece of redwood, so high that his legs didn't touch the floor. That was at the entrance to the showing of his big blocks of wood at Virginia Dwan Gallery.

Lynda Benglis

Pliny the Elder

Another of Phidias's pupils was Agoracritus of Paros… his youthful looks so delighted his master that the latter is said to have allowed him to take the credit for several of his own statues.

Life's always been fun, I've always enjoyed myself a great deal. The '60s in London were great fun… the group of young artists I was with… included people like Patrick Proctor and David Hockney. And we were always knocking on each other's doors — there were great parties at that time. I think partly because it was very difficult for people to go out: the bars were so grim. *10*

Derek Jarman
1942–1994

'You can always find somebody to beat up'
Carl Andre

AND THEN WE START BITCHING ABOUT HOW NONSENSICAL IT IS THAT SO-AND-SO WON THE TURNER PRIZE.

David Shrigley

'Each individual is unique and alone in an indifferent and often hostile world'

Lawrence Weiner

Christopher Wool
b.1955

Actually [Larry] Poons said something good that relates to art's isms. When asked if he considered himself a Pop artist or a Minimalist, he said Pop because they threw better parties. *11*

I shut myself within my soul/And the shapes come eddying forth.

Dante Gabriel Rossetti
1828–1882

Lawrence Weiner
b.1942

We live in a world where each individual is unique and alone — and this is the definition from a $1.98 dictionary of existentialism — in an indifferent and often hostile world. If one finds oneself by virtue of one's existence in an adversarial position to the world, if I find myself that way, then there must be at least another million people who do as well. That's a lot of people. That's a gold record. *12*

There was this gallery — Robert Elkon, who was Agnes Martin's dealer. He came to look at Jack's [John Wesley's] work and he never called me by the right name. He called me Joanne. So horrible. I'd say, 'My name is Jo: Josephine.' He paid no attention. 'Joanne, Joanne', he kept saying. So there we were, looking at Jack's work (Jack was working in the post office, so couldn't be there). And I suddenly said: 'Hello, David.' And then called him Henry, called him any name. After about an hour of this, he said: 'My name is Robert.' And I said: 'My name is Jo, or Josephine, Henry.' I refused to stop doing it, and put him in his place. They were that bad. It was normal. To make it very clear: people like Judd and [Mel] Bochner were saying, 'How can you like the work of a woman?'

Jo Baer

Pliny the Elder

Parrhasius and Zeuxis entered into a contest. Zeuxis produced a picture of grapes so true to life that birds flew up to the surface of the picture, while Parrhasius exhibited a linen curtain painted with such realism that Zeuxis, swollen with pride at the verdict of the birds, demanded that his rival remove the curtain and show the picture. Apprehending his error, he yielded the victory, freely admitting that while he had deceived the birds, Parrhasius had deceived him, an artist.

YOU WISH EACH OTHER WELL AND AT THE SAME TIME GO, 'OH NO, WHAT ABOUT ME?'.

Fiona Rae

David Shrigley All my friends are artists — Jonathan Monk, Richard Wright, Martin Boyce, Jeremy Deller. They're people I've known well for many years, to name but a few. Jonathan lives in Berlin — and whenever I'm in Berlin or he's over here, we sit around and talk about football, and then we start bitching about how non-sensical it is that so-and-so has won the Turner Prize.

Leonardo and Michelangelo strongly disliked each other, and so Michelangelo left Florence because of their rivalry (with permission from Duke Giuliano [de' Medici]) after he had been summoned by the Pope to discuss the completion of the façade of San Lorenzo; and when he heard this Leonardo also left Florence and went to France.

Giorgio Vasari
1511–1574

'We all considered painting and sculpture the noblest form of life to be had'

Tess Jaray

Edward Allington One of my big inspirations was Sol LeWitt. Not that I was his big drinking buddy or anything, but I took him as a role model. I was working at the Lisson Gallery one day, and Sol said: 'Oh, give me a lift to the restaurant.' I had a crap Renault, and I thought: 'Fucking hell, I'm driving Sol LeWitt — don't crash!' What was fabulous about Sol was that he was generous to other artists. I would swap works with him. There might be an artist who was broke, and he'd say: 'There's a drawing — sell it.' Which meant they could get through and pay the rent.

On the whole it was my contemporaries who had the greatest impact. Most of them, if they are still alive, are still working, some now have a serious body of work behind them, even though many have not really been acknowledged for the work they have produced over many decades. At the time everyone was deeply involved with painting or sculpture, we all considered it the noblest form of life to be had.

Tess Jaray

Larry Poons I'm not looking at other people's work in terms of anything technical. It's in terms of whether I like it. And you don't like everything, no one does. Except maybe in a Buddhist sense — in the sense of all things being equal — but we're not talking religion now.

Indeed, all his life Filippo [Brunelleschi] had to face competition from different men at different times; his rivals often tried to make a name for themselves by using his designs, and in the end Filippo was reduced to keeping everything he did secret and trusting no one. **Giorgio Vasari**

'The thought of a life immersed in the "art scene" is a nightmare'

Tess Jaray

David Shrigley I don't really think of myself as an outsider. I don't live in Glasgow any more, but up until 2016 we'd go for dinner with people, and there'd be two Turner Prize winners and three Turner Prize nominees around the dinner table, with their husbands and wives and kids. I've got Hans-Ulrich Obrist's phone number. And I'm friends with Kasper König. So I definitely don't feel like an outsider. I'm aware that the work is seen in that way, and that in some ways it is outsider art, as far as curators and collectors and writers are concerned. But I have the same life as other artists. You know: 'The Frieze art fair's coming up,' or 'The Basel art fair's coming up,' or 'Are you going to Basel this year?'

The thought of a life immersed in the 'art scene' is a nightmare. **Tess Jaray** Art doesn't come from that, although of course it's true that without it there wouldn't be any 'art' as such.

Pliny the Elder The reputation of some, although their work is distinguished, has been obscured by the number of other artists associated with them on a single commission, because the credit is shared, nor is it possible to give equal credit to members of a group.

FUCKING HELL, I'M DRIVING SOL LEWITT — DON'T CRASH!

Edward Allington

Notes

1 Grayson Perry, 'The Most Popular Art Exhibition Ever!', in Grayson Perry, *The Most Popular Art Exhibition Ever!* (London: Serpentine Gallery, 2017) 2 Sarah Lucas, '"the sound of the future breaking through" — Andrei Costache', in Iwona Blazwick (ed.), *Sarah Lucas: SITUATION Absolute Beach Man Rubble* (London: Whitechapel Gallery, 2013), 94 3 Damien Hirst, quoted in Sean O'Hagan, 'Damien Hirst: "I Still Believe Art Is More Powerful than Money"', *The Guardian*, 11 March 2012 4 Ian Hamilton Finlay, quoted in James Campbell, 'Avant Gardener', *The Guardian*, 31 May 2003, 22 5 Hirst, 'Damien Hirst: "I Still Believe Art Is More Powerful than Money"' 6 Howard Hodgkin, 'In the Studio', *Daily Telegraph*, 10 June 2016 7 Jackson Pollock, in a letter to his brothers Charles and Frank, New York (Los Angeles, 22 October 1929), reprinted in Francesca Pollock and Sylvia Winter Pollock (eds), *Jackson Pollock & Family, American Letters: 1927–1947* (Malden, MA: Polity Press, 2011), 16 8 Joseph Cornell's reported last words, quoted in Deborah Solomon, *Utopia Parkway: The Life and Work of Joseph Cornell* (London: Jonathan Cape, 1997) 9 Carl Andre, quoted in Barbara Rose, 'Carl Andre', *Interview*, June/July 2013 10 Derek Jarman in interview with Jeremy Isaacs, *Face to Face*, BBC television, 15 March 1993 11 Christopher Wool, quoted in Glenn O'Brien, 'Christopher Wool: Sometimes I Close my Eyes', *Purple*, issue 6, 2006 12 Lawrence Weiner, quoted in 'Lawrence Weiner by Marjorie Welish', *BOMB 54*, Winter 1996

On the scene

III

IV The professional artist

Edward Allington	Carle Andre
Francis Bacon	Jo Baer
Phyllida Barlow	Lynda Benglis
Billy Childish	Jesse Darling
Marcel Duchamp	Eric Fischl
Helen Frankenthaler	Nick Goss
Philip Guston	△ Raphael Gygax
Maggi Hambling	Ian Hamilton Finlay
Marsden Hartley	Damien Hirst
Howard Hodgkin	Winslow Homer
Tess Jaray	Derek Jarman
Chantal Joffe	Allen Jones
Leonardo da Vinci	Sarah Lucas
Joyce Pensato	Grayson Perry
* Pliny the Elder	Jackson Pollock
Larry Poons	Ged Quinn
Fiona Rae	Robert Rauschenberg
Mary Reid Kelley	Auguste Rodin
Ω Thaddaeus Ropac	James Rosenquist
Conrad Shawcross	David Shrigley
Luc Tuymans	Mark Wallinger
Richard Wentworth	# Oscar Wilde
Issy Wood	Christopher Wool

Artist	Results
Joyce Pensato	53,370
Conrad Shawcross	59,830
Peter Liversidge	74,200
Chantal Joffe	121,670
Mark Wallinger	121,670
Larry Poons	137,430
Phyllida Barlow	138,330
Edward Allington	148,000
Tess Jaray	155,000
Ged Quinn	202,670
Chris Ofili	202,670
Ian Hamilton Finlay	220,330
Philippe Parreno	220,670
Eric Fischl	284,330
Luc Tuymans	313,000
Philip Guston	315,330
Jo Baer	337,000
Howard Hodgkin	361,000
Maggi Hambling	371,330
Giorgio Vasari	375,670
Dante Gabriel Rossetti	388,330
Bruce Nauman	397,330
Jenny Saville	401,000
Mary Reid Kelley	403,670
Louise Bourgeois	410,670
Damien Hirst	419,330
Helen Frankenthaler	423,670
Jeff Koons	426,330
Richard Serra	433,000
Marcel Duchamp	440,330
Lynda Benglis	459,670
Tracey Emin	463,670
Auguste Rodin	474,330
Immanuel Kant	486,000
Anish Kapoor	505,000
Yoko Ono	505,330

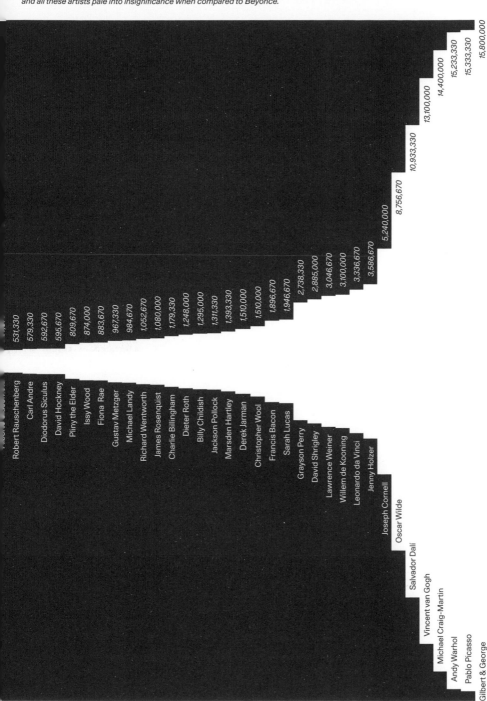

* Average number of search results on Google.com. Note that search results change day by day, and all these artists pale into insignificance when compared to Beyoncé.

How do we measure success in contemporary art? What does it mean to be a successful artist, as opposed to a good one? For many, the primary sign of success is being able to make a career out of art — to work as a 'professional artist'. Beyond this, many of the traditional measures of quality have fallen out of use. Today's artistic landscape is routinely defined in terms of 'plurality' and 'internationalism'. There is no single cultural standard for assessing quality — no hierarchy of subjects, styles or genres. For many, this represents a liberation and a leveller of the playing field. In a world of fragmented cultures and artistic micro-climates (or an anything-goes broth), recognition is achieved through subtler — some would say murkier — channels. Heavyweight curators, more than dealers or critics, have become the chief arbiters of success and discoverers (or rediscoverers) of 'talent'. Market value, too, has stepped in as a prevailing factor in determining 'worth' or 'quality'.

Success may be arbitrary and hard to define, but it is all too real for those who attain it or pursue it. And yet success has its sour notes, while failure brings slow and unexpected benefits. So how do artists broach these experiences, manoeuvring between the poles of triumph and disaster?

Tess Jaray
b.1937

The truth is that a good artist may be anything.

You've become a professional artist when you work seven days a week in the studio and get paid for three.

Ged Quinn
b.1963

Joyce Pensato
b.1941

What does it mean to be a professional artist? Does it mean you make a living out of it? I think my decision to embrace who I am, and really go for it, came all the way back in the '80s when my father died. This was what I was going to do, and I was going to make it, and not do a job.

'It's good to tell people what you think of them'
Richard Wentworth

In any group of people there are different kinds of quality. Some people are good-looking, some are funny, some are prescient, some make better luck than others, some are disgustingly talented, some people have a great turn of mind. It's good to tell people what you think of them, if you want them to tell you what you are good for. I'm interested in 'producers' — the kind you find in the theatre or film. Kurator was a good German word, curator is as woolly as a very old unloved sweater.

Richard Wentworth
b.1947

Ged Quinn

The downsides of becoming 'established': the treadmill. No holidays. Never reading for pleasure.

When I started out I would wake up in the morning and I would have to work at everything myself. By the end of the day — after a 12- or 15-hour day — I would be totally smashed, having done a lot of menial work, a lot of conceptual work, and a lot of maths and engineering on the backs of envelopes — just like a real polymath. It's been an interesting evolution: I've had to surrender control of everything, and become more a director, overseeing things, rather than a conceiver and a maker, and the person carrying through everything.

Conrad Shawcross
b.1977

IV

A LOT OF FAILURE VERY EARLY ON IS PERHAPS MORE USEFUL THAN A LOT OF SELF DELUSION. ASK A FRIEND.

Richard Wentworth

There comes a point where you're being treated like a public figure, which is a slightly uncomfortable feeling. Like everyone else, I'm quite a private person, so to have your opinion sought about a bunch of other stuff is quite a strange thing.

Recognition and rejection ↓

Howard Hodgkin
1932–2017

I don't consider myself very successful. Being well-known or having lots of exhibitions have nothing to do with being an artist, those things are just chance. *1*

The thing with a successful artist, is that it's all dependent upon who you work with, who supports your work, who is — in a longstanding way — organizing your career (which you do with your dealers).

Luc Tuymans
b.1958

Billy Childish
b.1959

I don't think there's any downside to success. My wife said to me: 'Maybe you should live in the better part of town, rather than the worst.' So I said: 'Okay then.'

'I don't consider myself very successful'
Howard Hodgkin

There are a number of artists who have been working under the radar for decades, no one really paying much attention, and often their work has become more and more interesting and challenging, because they are following their hearts, their own rules and demands and no one else's.

Tess Jaray

Conrad Shawcross

Ten years ago I probably thought I was the best person to do everything. But then there was a realization that there are better people out there — specialists. If you give someone a task eight hours a day, they're just going to get better at it than you.

But there is nothing to guarantee that they will ever become successful, which depends on so many factors totally removed from the quality of their work. — Tess Jaray

Jo Baer
b.1929

At my Stedelijk show in 2013, people like Rudi Fuchs and Kasper König — who have always kept me at arm's length, and never included me in their plans — each came up to me and said: 'I was wrong.' They still don't do anything with me now, but at least they suddenly realized what I was doing and how good it was. It was very interesting to see that happening.

I think failure is good. Well, you don't want too much failure — but I think that when José Freire cancelled my show, it shocked me into thinking about who I am, and what I'm doing. — Joyce Pensato

Ian Hamilton Finlay
1925–2006

At one period in my life, as a result of the poverty I was suffering, it became impossible for me to tell a lie. [2]

We all say, just try me, I can resist success, but I dare say it's rather tempting if the opportunity is there. — Tess Jaray

Mark Wallinger

Failure is about 99 per cent of it really. And if people don't recognize that then they're probably making some shoddy stuff.

If you are destined to burn out before you're 30 it would be a pity to have missed your successful moment. — Allen Jones
b.1937

Nick Goss
b.1981

I rarely find you learn much from a successful painting, but often the works that capsize and feel unsalvageable lead to the most exciting new places. You want art to reflect all aspects of life — including uncertainty, fragility and failure — and most of my favourite artists record their mistakes and indecisive moments directly into their work. Edvard Munch is a painter whose best works always look one brush stroke away from collapsing into failure.

'I think failure is good'
Joyce Pensato

When I showed at Parker's Box gallery in 2006, I had hit bottom: Joyce Pensato
I knew that I had a fantastic show, and if it had been anywhere else it
would have got a lot of attention. But it was in Brooklyn, where you just
get a couple of friends coming by. It got no attention at all. I was so bothered by it. I found
myself turning into one of these older artists complaining about stuff — and I hate whining.

Richard A lot of failure very early on is perhaps more useful than a lot of self
Wentworth delusion. Ask a friend.

So I thought: 'I know lots of people. I'm going to try to get them to help Joyce Pensato
— beg them.' I thought: 'Who is the most powerful person I know?
Christopher Wool and Charline von Heyl.' I said, 'I'm going to get
them over. I'm ready — I'm playing for the New York Yankees — I'm ready for the big time.'
I think I first called Charline, to get her over. Charline then said: 'Friedrich Petzel wants to come
over to do a studio visit.' And that was it. He saw a magazine article, saw the work, and wanted
to come over. That was the beginning of the beginning.

Jo Baer I'm not sure what failure is. I haven't been left out of anything that
I should have been in. But I'm not expecting to be a household name.

'I'm not sure what failure is'
Jo Baer

'There are many examples
of artists who become
victims of their own
success early on'

Thaddaeus Ropac

Fame then was achieved only by those who painted moveable pictures. Pliny the Elder
 23–79 AD

Thaddaeus There are many examples of artists who become victims of their own
Ropac success early on. I always say artists have 40, 50 or more years in
b.1960 which to work — and if things burn out early, it is immensely difficult
 to reinvent a career.

There are dangers to early success. The great advantage of being Raphael Gygax
young — at least as I remember it — is that you're fearless, that you're b.1980
NOW. That you want it — NOW. That creates incredible energy.
But it can also make you blind; often young artists think they deserve everything right away.
Of course that misconception is nourished by the press: you read all the time about super-
successful artists, new records. The idea of an absolute need to be successful immediately is
strongly embedded in our (neoliberal) society. A case in point that I experience often is: artist X
gets known for one specific kind of work and finally sells this work — via a young gallery,
at a reasonable price; then a bigger gallery comes, takes over (never forget it needs two to
tango), and continues to sell that 'recognizable' work, only for higher prices, maybe double.
For a moment: Paradise! You're 28, and you continue doing exactly the same work for three
years, perhaps once in pale pink and then in pale blue. The alteration can't be too great,
because you need to stay recognizable. Is that what you want? If so — go ahead and good luck
the market doesn't let you fall. I'm always happy to see artists who can sell on a steadier level,
stay freer, and therefore dare to experiment from time to time.

Facing criticism

Art criticism has been declared dead almost as often as painting. In the 1960s, when art was finally emancipated from codes of making and viewing that had held sway since the Renaissance, criticism too split into many channels, including theory, connoisseurship and plain-spoken journalism. Nowadays critical voices have multiplied into a never-ending stream. Yet writing on contemporary art today can often seem strangely cautious and qualified. Critics lapse into long and recondite descriptions, shying away from value judgements because accepted values have all but disappeared. In other quarters, as if to compensate, the critical tone is hectoring and dogmatic. But for all its vagaries, art criticism is an unavoidable — and often painful — fact of life for artists. Even a matter of life and death: the painter R.B. Kitaj is thought to have been driven to suicide by a coruscating review.

Carl Andre
b.1935

My life has been a chorus of 'How can you call that art?' *3*

Critics — who needs them? And you can't kill them. *4*

Christopher Wool
b.1955

Thaddaeus Ropac .

As much as a gallery is important, critics are important. They describe the artwork in a different way and create a context. Therefore it is crucial to have them describe and define the work.

We all care about a bad review, whether people like it or not.

Larry Poons
b.1937

Mark Wallinger

Obviously you don't want to be trashed. In a wider sense I think if there's a healthy critical atmosphere or debate abroad, then that's great. Most of the time you just hope that people will take notice, so you probably put up with bad or misguided receptions, as long as the work kind of got noticed.

But what I'm interested in is the phenomenon that we're all engaged in with ourselves. It's like when you catch yourself, when you're walking down the street — thinking about whatever it is you're thinking about — and you glimpse yourself unawares in a mirror. Think how immediately appalled we are. We primp, and we look at ourselves again, and then we immediately form another perception of what we've just seen. But the first moment — the moment that is pure, you might say — is the moment of, 'Oh my God, is that me?' The same thing happens in the studio. That moment of being caught unawares — we don't like it, not right away, if we ever like it at all.

Larry Poons

'It is crucial to have critics describe and define the work'
Thaddaeus Ropac

Billy Childish

Most of my interviews with journalists are conducted while I paint. People just come down to the studio and sit and chat with me while I make a painting.

What kind of man was I, sitting at home, reading magazines, going into frustrated fury about everything and then going into my studio to adjust a red to a blue? *5*

'In the best days of art there were no art critics'
Oscar Wilde

David Shrigley You have to be critical of yourself.
b.1968

I don't read art magazines anymore. As you get older and there are Tess Jaray
more and more artists, it's impossible to keep up. Does critical opinion
matter? I fear it does, though it's always worth remembering what
Picasso said: 'Don't read, just measure.' There are always a few — a very few — whose opinion
does seem to matter. And of course critics are often taken very seriously, mistakenly mostly.
Probably it's worse for an artist to be ignored. That's very difficult to fight.

Maggi Hambling I've never taken the slightest notice of fashion. And I've just gone
b.1945 on painting, because I think it can do things that nothing else can do.

I greatly value criticism, when it's from people who understand the Tess Jaray
work. It's very important, to me at least, to have one or two people
whose opinion I can ask. Sometimes others can see problems
that you are blind to, and when they're pointed out, then you can see
things differently.

Oscar Wilde In the best days of art there were no art critics. *6*
1854–1900

I decided, prior to completing my show at the Hayward Gallery in 2012, David Shrigley
that I was never going to read anything about my work ever again.
And I've stayed true to that ever since. I don't engage with what
people write anymore. That's just a coping mechanism, to be honest.
It's impractical to read criticism of your work, whether it's good or bad,
and I think that for me, it's been liberating.

YOU'VE BECOME A PROFESSIONAL ARTIST WHEN YOU WORK SEVEN DAYS A WEEK AND GET PAID FOR THREE.

Ged Quinn

'There are certain questions that only you can ask'

David Shrigley

Billy Childish
Most artists I speak to, if it does come up, remind me of what Tony Hancock said — every brush mark is torn from their body, and they fret and worry about what people might think about it. Whereas I don't.

It always matters what other people think because we're human. We're not machines. That's the reason we have perceptions to begin with, and also the reason we don't all have the same perceptions.

Larry Poons

Tess Jaray
In the press it is different. If it's favourable then the critics are very perceptive, if not, then they are idiots...

Everybody needs a response — you can't make the work in a vacuum — but you also need to think very carefully yourself about the work: there are certain questions that only you can ask. Most of the time, when other people write about it, they're having to express an opinion or to contextualize the work in a certain way. I'm not really interested in contextualizing the work, necessarily. I'm interested in the work relative to the work I've made before, and relative to my project as a whole.

David Shrigley

Fiona Rae
b.1963
In the end it's a more interesting project to develop yourself as an artist, than to be concerned with the categories that you're falling into. Of course I try to be aware of it. But it's hard to know how other people see you.

117

I read most of the press that I get. It does affect me. I suppose when it's more critical it affects you more. When it's more positive, it just sort of endorses what you've done. When it has been critical, I take it seriously and listen and try and think about whether it's justified, and what's wrong or what's right.

Conrad Shawcross

Lynda Benglis
b.1941
Critical writing has a place just as art has a place. Often it has meaning within a context, and you have to judge it in that way.

I feel that in order to be a great critic, you have to be a great writer. Larry Poons
The means of a great critic are singular. And you do not have to agree
with him. You can read George Bernard Shaw's art criticism or music
criticism, and not agree, and still have a great read. Like great painting:
we only find it three or four times every hundred years.

'It's cowboy land out there'

Fiona Rae

Richard I like a refreshing piece of writing but I don't get much of it. The PhD mill
Wentworth suggests a grinding down of the pleasures of language and invention,
 so PhD pills should be popped judiciously.

You've become a 'professional' artist, 1. when a piece of work leaves Issy Wood
the studio before you're ready to say goodbye to it; 2. when you're b.1993
claiming back a trip to the Tate on your taxes.

David Shrigley A lot of the time you get a response to a work: 'That's really good',
 'I like that', 'Why don't you just make that again?' — and I'm just like:
 'Well, fine, I've made that, and I'm not going to make it again. I under-
stand that you like it, and you might not like what I make subsequently, but there's no point
repeating myself because life's too short.'

[I have] been looking through all the reviews I've had from my Francis Bacon
Marlborough shows over the years and realizing that all of them, 1909–1992
virtually without exception, were bad. 7

Fiona Rae Reviews can be crushing — you just feel awful for a few days.
 Then you recover. Sometimes I think, 'I won't look at anything.'
 But I think it's hard not to. The best thing is not to look at anonymous
 comments on the internet, because there's a kind of wildness to them.
 It's cowboy land out there.

Pliny the Elder Apelles used to hide behind his pictures and listen to what faults people found, reckoning that the general public were more perceptive critics than he was himself.

The creative act is not performed by the artist alone; the spectator brings the work in contact with the external world by deciphering and interpreting its inner qualifications and thus adds his contribution to the creative act. *8* Marcel Duchamp 1887–1968

David Shrigley The responses that have an impression, sadly, are the ones from the gallery: 'Nobody bought any of those drawings.' But you really don't want to think like that about the work. That's sort of the same thing as some dude from the *Daily Telegraph* saying that your work's a lot of nonsense.

And I just think, 'Well, what am I going to do? Am I going to give up because this writer in this art magazine says I should give up?' Fiona Rae

Jo Baer I don't care — I find most reviews laughable.

'You've become a "professional" artist when you're claiming back a trip to the Tate on your taxes'
Issy Wood

Market

The art market is a defining feature of contemporary art — bigger than any artist, dealer, style or ideology. But it has existed in different forms since antiquity. Certain present-day bemoaners of the market forget that art has always been a commodity, and that artists have lived economic lives throughout history. And yet today's market can feel like an out-of-control global money machine, propelling and deflating careers as if on a whim. For some, this is a peculiarly modern malaise. The literary critic Terry Eagleton has written: 'If art mattered socially and politically, rather than just economically, it is unlikely that we would be quite so nonchalant about what is qualified for the title.' But from another perspective, the art market is an inescapable reality — baffling and occasionally infuriating — that simply confirms art's high cultural capital. It doesn't have to reflect a lack of power or meaning.

How do artists perceive the market, and how do they market themselves? Can they control their works' value, and should they attempt to?

The professional artist

IV

'Money is a huge part of our lives'

Damien Hirst

There are two metrics that hold weight in the art world. One is auction price: how much in cold cash someone is prepared to pay for a particular piece by a particular artist. The other is visitor figures — how many people go to see certain exhibitions. *9*

Grayson Perry
b.1960

Allen Jones

Posterity doesn't care about sales. The question is do you care about posterity?

Praxiteles had made two statues [of Venus] and was offering them for sale at the same time. One was clothed, and for this reason was preferred by the people of Cos who had an option to buy, although Praxiteles offered it at the same price as the other — this was thought the only decent and proper response.

Pliny the Elder

Edward Allington
1951–2017

I think the art world is important, but it's very contradictory. It can be confusing for students, coming from an academic system which is about questions. Sometimes you get into awkward positions. A dealer or collector will contact you, not because they're interested in you, but because they want to contact someone else through you. It's politics really, and I don't think I'm a particularly good politician. Mind you, are there any good politicians?

There are macroeconomic swirls going on that are nothing to do with what I do in the studio. You look at what's successful out there in the world, and who would have thought certain things would be incredibly popular in market terms, and that certain other things wouldn't be? Of course it's something I'm aware of, because it's how I make a living.

Fiona Rae

Ged Quinn

Unless you are making work that addresses the market head-on, it can — and does — stifle creativity.

I think a lot of people think that artists need to be poor, or that you can't have a focus on money... I think money is a huge part of our lives. I've always thought it's as important as love, or death, or something to come to terms with, something to understand. *10*

Damien Hirst
b.1965

Luc Tuymans There is no problem with earning a living, there is nothing filthy about it. I've worked very hard, and I think most of the other successful artists that I know — the good artists that I know — have done that too. But money cannot be the issue in itself: that would be detrimental, and you would have nothing left. In that sense, the whole auction thing that Damien Hirst did [in 2008] had an element of cynicism.

I think a lot of what gets reported is the very top end of the market and the auction brouhaha. What largely goes on is not what gets written about — someone can have a very successful museum career and not be making much money. A lot of artists need to support themselves with part-time jobs like teaching. **Fiona Rae**

'Scale is a creative problem as well as a logistical one'
Mary Reid Kelley

Luc Tuymans Although with Damien, it was not simply about becoming more rich. It was also a harsh critique of drivenness. I think many have misunderstood that. I don't think Damien started out just trying to make a truckload of money.

If you live beyond your means or you're not very truthful about its sources then all sorts of confusions may arise. We have all seen people do a lot with very little. **Richard Wentworth**

Tess Jaray If all the work you do is immediately bought and removed from your studio, then it's easy to see how there is the temptation to repeat yourself. If the work is still there, piling up in a corner and using up valuable space, there really is no point in doing the same thing again, and development can be more interesting, more exciting, although of course inevitably more difficult.

I think a danger to any artist, any time, are the problems involved in increasing the speed or scale of production in response to demand. Scale is a creative problem as well as a logistical one. **Mary Reid Kelley** b.1979

Keeping going

Keeping going can be one of the toughest aspects of the life of an artist. Success is frequently a spur, and yet the attention it brings can equally be inhibiting — particularly for young artists who attain sudden recognition, and then struggle to innovate and develop in the glare of popularity and publicity. Many artists' lives are stories of long perseverance in the face of little or no recognition. Success, when it arrives, has usually been hard won. In the meantime, economic necessity may require an artist to find a job — teaching, technician work, or (in Jeff Koons's case) commodities brokering. As for writers, creative block may set in, or life may get in the way of art: many great artworks are unfinished (perhaps the greater for being so), from Michelangelo's *Slaves* to Rodin's *Gates of Hell* to Kurt Schwitters's *Merz Barn*. But does an artist — whatever their setbacks, and however sidetracked — ever stop being an artist? Is there ever a temptation — is it even possible — to give up art?

BEING 'MID-CAREER' IS DIFFICULT: YOU'RE NOT THE NEW HOT THING AND YOU'RE NOT THE OLD HOT THING.

Fiona Rae

Pliny the Elder There have also been women painters ... Iaia from Cyzicus, who never married, painted with a brush at Rome, and also drew on ivory with an engraving tool: she did mainly female portraits, including a large picture on wood, *Old Woman at Neapolis*, and a self-portrait done with the aid of a mirror. No one produced a picture faster than she did, and her artistic skill was so great that in the prices her pictures fetched she far exceeded the most famous portrait-painters of the same period, namely, Sopolis and Dionysius, whose pictures fill the art galleries.

I'm thinking about the moment all the time. But also I'm thinking about **Lynda Benglis**
where I'm going to go. I have these 'stations' where I learn and meet
different people. For instance, I go to India a lot.

Larry Poons You're always stopping, because there are other things that happen.

But in the end it's like a horrible siren on a rock calling me back to my **Fiona Rae**
lonely studio.

Jo Baer When I was in California, I gave art up for two weeks — and got bored to death. Everything was good — sex life was good, everything fine. And I thought, 'Why do I have to go through this? It's hard work, it's really hard work.' So I stopped for two weeks. It's a hard life but it's all I can do and I'm bored if I don't do it. And it's really not that I'm so good at it, it's just that my mind works this way.

'You never really stop thinking about ideas'
Conrad Shawcross

I don't think an artist can stop being an artist. You may have a hiatus in **Conrad**
making things, but I think from the artists I know and the way that I think, **Shawcross**
it's so hardwired into your way of thinking, that you never really stop
thinking about ideas, even when you're on holiday or when you're relaxing. It's the constant
endeavour of trying to solve a problem or come up with a new idea. It's never-ending.

'You can't really stop being an artist. It's just not possible'

Conrad Shawcross

Art would have to give me up, rather than the other way round. **Tess Jaray**
It's such a strong compulsion, obsession, whatever you want to call it,
that it becomes what you are, for better or worse.

Fiona Rae

Being 'mid-career' is difficult: you're not the new hot thing, and you're
not the old hot thing. You're the thing in the middle that everyone
thinks they know and has made up their mind about. I think that in
the last couple of years, I've been doing some of the most exciting
works yet.

Economically it's so tough to live in London and support yourself **Phyllida Barlow**
as an artist. There should be no snobbery about going on a teacher **b.1944**
training course or something like that, which will give you an income
to survive while you make your own work, albeit in the little spare time
you have. *11*

Larry Poons

Once you've done your painting, it's done. Then the rest of it is a business
situation. It becomes a commodity.

And if you decide to stop making something — to stop making work **Conrad**
for a bit, because there's a problem or you've reached an impasse **Shawcross**
— you've found yourself in a cul-de-sac that you need to resolve.
You can't really stop being an artist. It's just not possible.

Larry Poons

Well, everybody who's ever done anything gets depressed. What would
we have done if Beethoven had stopped writing music because he got
too damned depressed all the time (and he did, all his life)?

WHEN I WAS IN CALIFORNIA, I GAVE ART UP FOR TWO WEEKS — AND GOT BORED TO DEATH.

Jo Baer

Routine

Routine is crucial for some and non-existent for others. Contrary to romantic tales, most good art arises from long hours of hard work or hard thought, with some luck or inspiration thrown in. Many artists treat that work as if it were a nine-to-five job. But hard work can also be a sustained mental state and a committed way of life — not simply the clocking up of hours in the studio.

The professional artist

IV

When I was at Saint Martin's, I would make about three or four hundred **Billy Childish**
paintings during the summer. Once I was expelled, I decided to make
between two and five a day, on one day, every week. And that's what
I carried on doing.

Fiona Rae I tend to come into the studio a lot, but then I get tired and I don't come
in for a day or two. When I'm really into something I work late, but I try
not to — because I don't notice that once I'm tired I get destructive.

I only paint on Monday and Sunday. I paint so fast and so many, even **Billy Childish**
that's too many. For the rest of the week, I work on my writing, I do the
washing up and cooking.

Howard Hodgkin How long I paint for each day varies, because I don't have many
ideas, and often when I have them, they suddenly vanish. In that case
it's best to stop and wait for another day. I often take a nap to escape
from one thing or another; usually other people's disappointment. *12*

There are rules that I have learned over the years. If I'm here after 7.30, **Fiona Rae**
the chances are it's going to go downhill pretty quickly. Eight o'clock
borderline. In the past I would work until really quite late, and just
destroy everything.

Jackson Pollock I don't see why the problems of modern painting can't be solved as
1912–1956 well here as elsewhere. *13*

Having had an incredibly exotic, turbulent childhood — with a lot **Fiona Rae**
of moving — has made me want to stay where I am. J.G. Ballard just
stayed in Shepperton. I find that quite encouraging.

'I only paint on Monday and Sunday'
Billy Childish

Moving around

For all the uncertainty and struggle, the life of an artist can be — at its best — extraordinarily liberated. Few other people, excepting students, have the same opportunity to determine their own move-ments and set their own agenda. For artists throughout history, the freedom to live and work in different places has been a vital creative stimulus. They have taken inspiration from the cultures, people, land-scapes or light of other places. Travel grants and residencies continue to allow artists to move around. But there is another kind of artist — the one who stays put, travelling little or not at all, sometimes barely leaving the micro-world they have created around them.

Tess Jaray I worked in the same studio for fifty years, and then moved to my new one some three years ago. Which I love — it used to be the saloon bar in an old pub, and with any luck I'll remain here the rest of my life.

'If you're a painter, you only need one thing — colour'
Larry Poons

Sometimes you feel you just have to shake it up. I've done this many times with many moves. I've had studios in Liverpool, Edinburgh, Düsseldorf, London, St Ives, Amsterdam, Bristol, Porta Rosa… Ged Quinn

Marsden Hartley 1877–1943 There is never a time I don't feel homeless. But I was born that way and it will probably be like that always.

It doesn't matter where you are, because you can't shut off perception. Larry Poons

Maggi Hambling I don't listen to anything. I try to listen to whatever's inside me. I don't understand how people can paint with Radio 4 on.

Richard Feynman, who was a physicist, and used to travel all over the world — speaking, teaching — was once asked: 'Where's your favourite place to work?' He said: 'My favourite place to work is the kitchen table.' That's not a wise-guy answer. In point of fact, it's a wise-guy question — no offence. He's saying, I need a pencil and paper and a table. Every place has a kitchen table or something akin to it. If you're a painter, you only need one thing — colour — because that's all a painting is. Larry Poons

'Artists are the product and the poultry both'

Jesse Darling

Joyce Pensato Early on, in that old studio, I had no heat. So I would go off to Paris in the winter. I would stay there for eight or nine months. I don't speak a word of French.

I have several spaces all over the world, in Greece, in New Mexico — outside Santa Fe and inside Santa Fe — New York. I find it hard to give any of them up. I need those separate 'shells', those separate spaces that seem to mark parenthetical times. I can go back and forth, and realize that I've changed, and that those spaces offer some compatibility with history. **Lynda Benglis**

Jesse Darling The best part of being an artist is the flexibility and autonomy and joy
b.1981 that come from the prerogative to pursue adventures in one's own mind. The worst part is that there's no security and very little care; artists are the product and the poultry both, and this is hard to navigate while trying to maintain dignity and integrity.

Every place is like every other place. I noticed that the light in Spain **Larry Poons**
was very similar to the light in New York City. It's the same latitude, that's why. The south of France has the same light as New York City. It's not what it looks like: you feel light before you notice it. And again, how can you teach 'light'? You can't teach feeling.

Lynda Benglis I'm stationary for as long as I want to be in a place, but when I get tired of that place, I move on.

Holland, along with Japan, has the best graphic artists in the world. Jo Baer
They're very bad painters, but their graphics are great. For whatever
reason — the flatness of the country, the shallowness of the graphic,
I really don't know. What has happened to me, living in Holland for all this time, is that every
idea I have starts as a graphic rather than a painting. It's like Jacob wrestling with the angel to
get it into a painting. So something has turned me into a graphic artist, which is no good at all.
They say, does it matter where you live? It even matters if you change studios!

Joyce Pensato At one point I had a really successful show in Paris and the work sold.
I got into the system. I thought I was going to live there half the time,
and half the time in New York. But it didn't quite work that well.
9/11 happened, and I felt I had to start over. I thought: I have to start almost like a newcomer.
I had a friend who had a gallery, Parker's Box in Brooklyn, and he gave me some opportunities
— I had a one-person show there in 2006.

I'd love to go somewhere else. I daydream about it all the time. I need Fiona Rae
the freedom and the time to fail, which isn't as pessimistic as it sounds.

Edward I'm really hacked off about this Brexit shit. I've always seen myself
Allington as a European artist travelling around the world. I do have some
Scottish heritage, so if next time we meet I'm wearing a kilt, you'll just
have to live with it.

I can't go somewhere and think, 'In four weeks I know I'm going Fiona Rae
to make three paintings.' It doesn't work like that with me. I can go
somewhere, and make all that effort, and have nothing to show for it.
I did do a residency actually in 1990 at the Cartier Foundation [Paris].
I don't think [the residency] exists any more. But I didn't stay very long,
because they gave me a flat I couldn't really stand up in.

Jo Baer I didn't wish to stay in New York, because I was successful there and
I wished to change my work and they don't let you.

'How can you teach "light"?
You can't teach feeling'
Larry Poons

Inspiration and chucking out

Creation is also a process of reassessment, deletion and destruction. Inspiration tends to be elusive — and the likely success or failure of an artwork can be equally hard to gauge in the moment of making. Works coalesce out of shifting sets of conditions, or what T.S. Eliot referred to as 'decisions and revisions which a minute will reverse'. Artists have always chucked out the bad stuff (and very often the good stuff too — Francis Bacon regretted destroying a number of paintings, in retrospect). In 1970 John Baldessari consigned his entire corpus of paintings to the flames, and embarked on the conceptualist works with which he made his name. Destruction was a necessary purge. Not all artists, though, have felt the need to self-edit: Pablo Picasso and Andy Warhol are just a couple of those for whom nothing, seemingly, was worth losing.

'White paper and white canvas are truly terrifying things'

Fiona Rae

Fiona Rae

White paper and white canvas are truly terrifying things. You just have to make a mark, and the next thing is a conversation with that mark. Maybe it's like that with writing — even if your first sentence isn't that great, at least you've started.

Tess Jaray

I've always enjoyed writing, partly because it comes easily to me, unlike painting, which is the most difficult thing in the world, and partly because it doesn't matter so much. If I fail to get something down on paper, or express it badly, I just throw it away and it doesn't bother me. Whereas failing with a painting can seem like the end of the world.

Billy Childish

I don't know beforehand what I'm going to paint, and I don't look for anything in it, and I don't mind if I don't like what I do. I don't make paintings that I want to make, I make the paintings that ask me to make them.

Maggi Hambling

I'm never really in charge of things. I know it sounds easy to say, but it is true that life dictates what I do. I don't dictate to it.

Leonardo da Vinci
1452–1519

If you look upon an old wall covered with dirt, or the odd appearance of some streaked stones, you may discover several things like landscapes, battles, clouds, uncommon attitudes, humorous faces, draperies, &c. Out of this confused mass of objects, the mind will be furnished with abundance of designs and subjects perfectly new. *14*

Ian Hamilton Finlay

A lot of my work is to do with straightforward affection (liking, appreciation), and it always amazes me how little appreciation for ANYTHING there is in art today. *15*

Larry Poons

Tell me why you like the look of that mountain — I don't need a reason to like the look of that mountain, because my brain gets it at the speed of light. I already like it before a word can be formed. Our visual perceptions are the fastest means that we have of communicating with ourselves — between our brains and the outside world.

I DON'T MAKE PAINTINGS THAT I WANT TO MAKE, I MAKE PAINTINGS THAT ASK ME TO MAKE THEM.

Billy Childish

David Shrigley When Martin Creed did that show at the Hayward, it was called, 'What's the point of it?' I always ask myself that question before I make an artwork: what's the point of it? I think his question was far more wide-reaching. But when I ask myself that question, it's just a case of, don't do the same thing twice, and don't do anything that you don't really need to do.

I never had to deal with loss of inspiration. Too many ideas to get out Ged Quinn
and I work slowly. So I'm always behind schedule.

Issy Wood One of the best aspects of being an artist is the travel, and the dinners (the art world seems to have brilliant taste in food — I think of Margot and Fergus Henderson and how many London artists' metabolisms they keep in check).

There are times when you just think, 'I don't know what to do, I literally Fiona Rae
have no ideas.' But then if I start something, and force myself to continue with it, after a while, the ideas start coming. In the making of things, ideas start to happen. I guess that's one of the things I've learned over the years — just start something. Make something start to happen, and then you'll have the ideas.

Maggi Hambling There are days when you do absolute shit, which has to go.

I throw out I can't tell you how many paintings a year. I mean for every Helen
one that I show there are many, many in shreds in garbage cans. *16* Frankenthaler
1928–2011

'I throw out I can't tell you how many paintings a year'

Helen Frankenthaler

Joyce Pensato I destroy whatever isn't good — a lot of stuff. Sometimes I wish I hadn't. I wish I could take a look again. But I think some of it was worth destroying.

You spend three months on them and then it's as if nothing ever Maggi Hambling
happened. I cut the canvases off the stretchers and cut them up. Got to be done. Too much bad art about. It's got to be done.

What I have in mind is that art may be good, bad or indifferent, but, whatever adjective is used, we must call it art, and bad art is still art in the same way as bad emotion is still an emotion. *17*

Marcel Duchamp

Richard Wentworth

Being prolific suits some personalities, but it is not always the same as being productive. Making products might be compared with what we leave in the lavatory pan, so you need a good sense of purpose.

Inspiration — that reminds me of what Thomas Merton once said about prayer. He was a writer who became a Trappist monk. He was asked about prayer, and he said: 'Don't you think, if there was a God, that God would know what it is that you feel?' All this asking for forgiveness, when you think that you're praying — that's not prayer. So then you say, what is inspiration? It's not something you can talk about.

Larry Poons

Mary Reid Kelley

I don't worry that creativity (whatever it is) will run out or expire. But a person can, and exhaustion and overcommitment will rob you and your work.

An artist, to achieve anything in art, has to finally do the thing that nobody else wants to do and nobody else has thought to do. *18*

Carl Andre

Lynda Benglis

You do something, and the work looks back at you. If something has meaning, it does that — it is a vocabulary.

I developed the masculine part of my mind, so that I can do men's abstract art quite easily, and just leave it there. But what I did was, I actually included female things — a different way of using colour, a different way of looking at the work.

Jo Baer

'I envy people who have a plan and then follow it through'
Fiona Rae

'Art may be good, bad or indifferent'
Marcel Duchamp

Tess Jaray 'Inspiration' is a word one hardly dares use, but is probably at the root of much art, in one form or another. Sometimes it just vanishes after a long or a particularly intense period of working, and you feel completely drained of everything, and lose all belief that you will ever find inspiration again. It's incredibly hard to deal with, all the meaning in life seems to drain away. I've never really found a way of dealing with it, though in recent years I've learned that if I stop trying so hard to resolve something then it can, with luck, resolve itself.

I think there always needs to be a moment at the end of it when you're **David Shrigley** just like: 'I don't really know why I did that, but I'm kind of glad that I did it. I think it's really interesting, and I still don't understand it.' Whereas I think that if you understand it from the moment you've done it, somehow it's closed. It doesn't go anywhere. There has to be some kind of risk. It isn't just a matter of executing a plan.

Tess Jaray If we don't know where it comes from there is no key to open the door again, and you just have to keep turning till it does open. Clearly the unconscious mind goes on working at it all the time.

Every artist suffers from block or doubt. You deal with it by carrying **Howard Hodgkin** on working. *19*

Fiona Rae Sometimes by ploughing on, you get to another interesting place. You just never know. It's a heartbreaking working process, really — you spend hours and days on something, and then have nothing to show for your effort. But that's just the nature of the beast. Especially with painting that is improvised. I envy people who have a plan and then follow it through.

You only know in retrospect whether the work is any good. But you know if it's shit, and if it's shit, then just don't do it. A lot of the time I don't even start. I have ideas for work, and I constantly say to myself: 'Why am I doing that? Do I need to do that? Does that really need to exist, that idea?' David Shrigley

Maggi Hambling Imagination is reckoned to be 99 per cent memory.

I think it was Henry Moore who was asked where he got his ideas for his sculptures, and he said something like, 'I continue to do as an adult the things I did as a child.' I think that's what art is about. 20 Carl Andre

Nick Goss You have to approach the work with your own memories and ideas and these thoughts gain traction in the spaces in the work. It's interesting to leave lacunas or sinkholes in the images that the viewers have to negotiate. Most of my favourite artworks have that capability.

As an artist, the thing that I am really excited by is just making the work, and nothing else. David Shrigley

Fiona Rae Stuff that feels incredibly momentous in the studio can seem like the tiniest shift outside.

Making the work is really exciting and important, but also feeling that you're just at the beginning of something. That's the one thing — the one feeling — that I always want to preserve. David Shrigley

The professional artist

IV

'You know if it's shit, and if it's shit, then just don't do it'
David Shrigley

I DON'T REALLY KNOW WHY I DID THAT, BUT I'M GLAD I DID IT. I THINK IT'S REALLY INTERESTING, AND I STILL DON'T UNDER-STAND IT.

David Shrigley

Influence — finding a place in art history

Influence is an overused word in art history, one that collapses together multiple shades of meaning. What do artists mean when they talk about their influences? There are clear-cut instances of homage and emulation; but there are also more subliminal threads that connect artists and artworks, sometimes across long historical removes — threads that have a subtler meaning than the 'cause and effect' relationship typically implied by 'influence'. Even rejection of a given artist or style or idea is a paradoxical form of acknowledgement.

The anxiety of influence, as Harold Bloom seminally theorized it, prompts artists to square up to their forebears in a spirit of dual reverence and rivalry. It is all the stranger and more potent when it plays out among friends or contemporaries. Influence, in these cases, can transmute into false guises, such as envy or professed indifference. Or it can announce itself openly.

'Old blokes down the pub are my main influence'

Sarah Lucas

Sarah Lucas
b.1962

I like going down the pub. I like knocking about with blokes. Old blokes down the pub are my main influence. *21*

Art history: do you think that the more you know about literature, the closer to Herman Melville you might become?

Larry Poons

Fiona Rae

Going to see shows, particularly painting shows, I see as a kind of homework. In order not to stultify, you need to keep looking at stuff, keep challenging yourself.

My work with [Thomas Hart] Benton was important as something against which to react very strongly, later on; in this, it was better to have worked with him than with a less resistant personality who would have provided a much less strong opposition. At the same time, Benton introduced me to Renaissance art. *22*

Jackson Pollock

Helen Frankenthaler

[What I learned from Pollock was] being able to know when to stop, when to labour, when to be puzzled, when to be satisfied, when to recognize beautiful or strange or ugly or clumsy, and to be free with what you are making that comes out of you. *23*

Everything in our existence, everything that comes by you or past you that you don't know you've picked up, you do pick up. Everything, in its time, may or may not influence you. Whether you knew Velázquez existed, or that artist or writer existed — none of that makes you a better artist. It might enrich your life, and it puts you in touch with stuff, but no more so than walking into a library and picking out books.

Larry Poons

Christopher Wool

Poons was very important to me when I was younger. I studied with Jack Tworkov when I was 17, and he explained to me what Poons's dot paintings were all about and how they worked optically. I still love those paintings. *24*

My mother, who liked art, was told to draw by some nuns in a hospital. She happened to have a Presbyterian minister, and it scared her to death. But when she got out of the hospital she sat us down and drew our portraits. She had a copy of a Gauguin on her dresser after that, and it was of two women portrayed from the waists up. Their breasts were showing and I remember that they looked like my mother, because my mother also had brown titties. These things are cues. They open up questions.

Lynda Benglis

Joyce Pensato I've been consistently the same for many years. I've found my language, and I was very lucky to find my language early on. It was about cartoons, and American pop culture.

'I've been consistently the same for many years'
Joyce Pensato

Artists of my generation... were not given the equipment, because it was generally believed to be irrelevant. Drawing, eye-hand co-ordination, art history — really fundamental stuff — were considered unnecessary. Paying too much attention to history would just clog your mind, make you imitative instead of avant-garde. *25*

Eric Fischl
b.1948

Joyce Pensato There's a combination in my work of art history and pop culture, which are neck and neck. I used to go to museums and drool over the artists that I loved — the Museum of Modern Art in New York, and the Metropolitan.

Kurt Schwitters, he's allegedly responsible for contemporary collage, but my experience was going to work for Artkraft Strauss Company with a lot of dissimilar material sitting on a desk. *26*

James
Rosenquist
1933–2017

Derek Jarman
1942–1994

I wanted to be a painter, I never wanted to be a filmmaker. I pottered through all the 'isms' — Cubism and Taschisme — and I finally caught up with straightforward English landscape painting. I found myself down at Kilve in north Somerset where my aunt lived, just painted the fields. *27*

I've seen [Chaïm] Soutine's photographs in the Barnes Collection [Philadelphia], and that made me think of Rembrandt's portraits. That makes my skin prickle, because painting is an endless looping back on itself, but then a kind of edging forward at the same time.

Chantal Joffe
b.1969

Eric Fischl There are moments when you are looking at a work that is hundreds of years old and it's talking to you. You feel connected to the artist; he is transmitting a kind of truth, and it works today the way it worked then. *28*

My liberation from academicism was via Michelangelo. He is the bridge by which I passed from one circle to another. He is the powerful Geryon that carried me. 29

Auguste Rodin
1840–1917

Winslow Homer
1836–1910

I wouldn't go across the street to see a [William-Adolphe] Bouguereau. His pictures look false; he does not get the truth of what he wishes to represent; his light is not out-door light; his works are waxy and artificial. They are extremely near being frauds. 30

It was Leonardo da Vinci's *Annunciation* that provided the shock which made me paint as I do now. 31

Robert Rauschenberg
1925–2008

Larry Poons

We're instantaneous-recall machines. Someone like Picasso, of whom there are very few every hundred years, seemed to do it better than anybody else. I call it involuntary total recall. The person doesn't desire it; it's just the way it comes out in a particular situation. Everything that had passed through Picasso's computer — whether he knew it or not — every colour and shade came into play when he had a pencil and paper.

Precisely why some things enter the deep mine of culture and stay there is a puzzle, but very pleasurable, almost erotic, to wonder.

Richard Wentworth

'Painting and poetry are bedmates. It's about what cannot be said'
Jo Baer

Jo Baer

Real painting, that's something I'm deeply in love with. I've likened it to its closest relative, poetry. I like Dylan Thomas, and [Joseph] Brodsky, and Eugenio Montale. I liked a lot of the Irish poets, not so much Seamus Heaney. Painting and poetry are bedmates. It's about what cannot be said. My work has meaning and context on the top, but underneath it works with structure — deep structure. I am actually trying to ask, 'Who are we? What is hardwired in us?' I am using painting to go as deep as I can into structure.

The influence thing's a bit spurious really, because actually, we must be so influenced by so many things we don't even realize. We can't take the past or the present reality out of things, because they're part of all our state of affairs.

Larry Poons Who did the cave paintings in France? It's simple, it's very simple: the women did. The men were out hunting, they were killing their fucking enemies — that's what the men did. The women stayed at home with the children; the home was inside the caves. So who painted the pictures? The women! They were the first painters. It was also the beginning of the first movies, I think, because the paintings on the walls would start moving with the light from the fires. Not prehistoric, modern! Has anyone not lived in modern times? It's always been modern for anybody living in it. We think there's some special category of Modernism. It's what mankind has always lived with.

I personally think that the classical is the basis of Modernism. Edward Allington

Sarah Lucas The thing about all these artefacts that have been knocking around for centuries is that they've retained their power. Even though we really don't know what they meant, or how people exactly related to them. And I suppose if you set about making something, the point is to do it with some kind of power, otherwise it doesn't work. Not that it has to be presented in a similar way.

I can't think of anything better than somebody saying, 'That's a bit like Chantal Joffe the Venus of Willendorf.' How great is that?

Sarah Lucas It is a tricky thing, because culture can move on so fast that things get obsolete, and I don't know where that leaves us. But there still is a kind of touchstone.

'Culture can move on so fast that things get obsolete'
Sarah Lucas

BAD ART IS STILL ART IN THE SAME WAY AS BAD EMOTION IS STILL AN EMOTION.

Marcel Duchamp

Notes

1 Howard Hodgkin, 'In the Studio', *Daily Telegraph*, 10 June 2016 *2* Ian Hamilton Finlay, quoted in James Campbell, 'Avant Gardener', *The Guardian*, 31 May 2003, 22 *3* Carl Andre, quoted in Barbara Rose, 'Carl Andre', *Interview*, June/July 2013 *4* Christopher Wool, quoted in Glenn O'Brien, 'Christopher Wool: Sometimes I Close my Eyes', *Purple*, issue 6, 2006 *5* Philip Guston, quoted in Irving Sandler, *Art of the Postmodern Era* (New York: Harper-Collins, 1998), 196 *6* Oscar Wilde, 'The Critic as Artist' (1891) *7* Francis Bacon, quoted in Richard Cork, 'A Visit to Bacon's Studio', 4 October 1971, reprinted in Richard Cork, *Everything Seemed Possible: Art in the 1970s* (New Haven and London: Yale University Press, 2003) 291 *8* Marcel Duchamp, 'The Creative Act', 1957 *9* Grayson Perry, 'The Most Popular Art Exhibition Ever!', in Grayson Perry, *The Most Popular Art Exhibition Ever!* (London: Serpentine Gallery, 2017) *10* Damien Hirst, quoted in Henri Neuendorf, 'According to Damien Hirst, You Can't Make Art without Money', Artnet, 19 May 2016 *11* Phyllida Barlow, quoted in Mark Godfrey, 'Learning Experience', *frieze*, 2 September 2006 *12* Hodgkin, 'In the Studio' *13* Jackson Pollock, quoted in 'Jackson Pollock: A Questionnaire', *Arts and Architecture*, February 1944 *14* Leonardo da Vinci, quoted in Ian Chilvers (ed.), *The Oxford Dictionary of Art and Artists*, fifth edition (Oxford: Oxford University Press, 2015) *15* Ian Hamilton Finlay, quoted in Tom Lubbock, 'Ian Hamilton Finlay', *The Independent*, 29 March 2006, 50 *16* Helen Frankenthaler, quoted in Barbara Rose, 'Oral History Interview with Helen Frankenthaler', 1968 *17* Duchamp, 'The Creative Act' *18* Andre, 'Carl Andre' *19* Hodgkin, 'In the Studio' *20* Andre, 'Carl Andre' *21* Sarah Lucas, quoted in Sadie Coles, 'Situation', *POP* magazine, issue 24, Spring/Summer 2013 *22* Pollock, 'Jackson Pollock: A Questionnaire' *23* Frankenthaler, 'Oral History Interview' *24* Wool, 'Christopher Wool: Sometimes I Close my Eyes' *25* Eric Fischl, quoted in Frederic Tuten, 'Fischl's Italian Hours', *Art in America*, November 1996, 79 *26* James Rosenquist in interview with Jane Kinsman, Florida, May 2006 *27* Derek Jarman in interview with Jeremy Isaacs, *Face to Face*, BBC television, 15 March 1993 *28* Fischl, 'Fischl's Italian Hours' *29* Rodin in a letter to Antoine Bourdelle, 1906 *30* Winslow Homer, quoted in Sarah Burns, *Inventing the Modern Artist: Art and Culture in Gilded Age America* (New Haven; London: Yale University Press, 1996), 42 *31* Robert Rauschenberg, quoted in André Parinaud, 'Un "Misfit" de la Peinture New Yorkaise se Confesse', *Arts*, no. 821, 10 May 1961

The professional artist

IV

V Experience

Experience

Carl Andre

Francis Bacon

Jo Baer

Lynda Benglis

Billy Childish

Jesse Darling

Tracey Emin

Maggi Hambling

Damien Hirst

David Hockney

Howard Hodgkin

Sarah Lucas

Joyce Pensato

Larry Poons

Fiona Rae

*Thaddaeus Ropac

Conrad Shawcross

David Shrigley

Lawrence Weiner

Richard Wentworth

Highest prices at auction*

Under $500,000,000

$450,312,500
Leonardo da Vinci
2017

$179,365,000
Pablo Picasso
2015

$142,405,000
Francis Bacon
2013

Under $50,000,000
Enlarged ×500 per cent

$29,930,000
Christopher Wool
2015

$28,165,000
Louise Bourgeois
2015

$516,500 Philippe Parreno 2017	*$841,874* Grayson Perry 2017	*$905,000* Sarah Lucas 2014	*$1,874,500* Eric Fischl 2009	*$2,246,882* Howard Hodgkin 2017	*$2,589,770* Anish Kapoor 2008	*$2,830,0* Helen Frankenthaler 20
	$574,500 Giorgio Vasari 2000	*$881,000* Jenny Holzer 2008	*$1,157,000* Larry Poons 2014	*$2,165,000* Carl Andre 2008	*$2,513,647* Gilbert & George 2008	*$2,699,750* Luc Tuymans 2013

Under $500,000
Enlarged ×50,000 per cent

$198,191
Michael Craig-Martin
2016

$132,000
Rachel Howard
2008

$88
Diet
2014

$222,194
Jo Baer
2015

$245,000
Lynda Benglis
2014

$185,000
Lawrence Weiner
2015

$116,500
Yoko Ono
2010

$257,119
Ged Quinn
2011

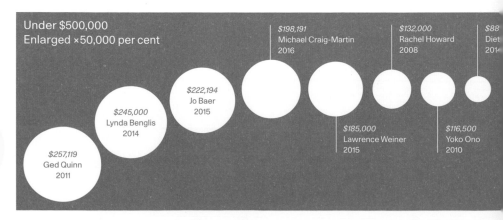

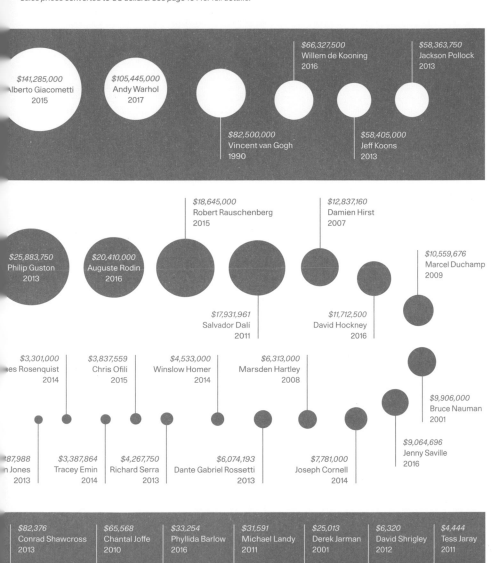

$141,285,000
Alberto Giacometti
2015

$105,445,000
Andy Warhol
2017

$66,327,500
Willem de Kooning
2016

$58,363,750
Jackson Pollock
2013

$82,500,000
Vincent van Gogh
1990

$58,405,000
Jeff Koons
2013

$25,883,750
Philip Guston
2013

$20,410,000
Auguste Rodin
2016

$18,645,000
Robert Rauschenberg
2015

$12,837,160
Damien Hirst
2007

$10,559,676
Marcel Duchamp
2009

$17,931,961
Salvador Dalí
2011

$11,712,500
David Hockney
2016

$3,301,000
...es Rosenquist
2014

$3,837,559
Chris Ofili
2015

$4,533,000
Winslow Homer
2014

$6,313,000
Marsden Hartley
2008

$9,906,000
Bruce Nauman
2001

$9,064,696
Jenny Saville
2016

...87,988
...n Jones
2013

$3,387,864
Tracey Emin
2014

$4,267,750
Richard Serra
2013

$6,074,193
Dante Gabriel Rossetti
2013

$7,781,000
Joseph Cornell
2014

$82,376
Conrad Shawcross
2013

$65,568
Chantal Joffe
2010

$33,254
Phyllida Barlow
2016

$31,591
Michael Landy
2011

$25,013
Derek Jarman
2001

$6,320
David Shrigley
2012

$4,444
Tess Jaray
2011

$5,986
Richard Wentworth
1990

...459
...k Wallinger
...6

$74,841
Fiona Rae
2015

$47,818
Joyce Pensato
2015

$31,619
Billy Childish
2013

$30,768
Maggi Hambling
2015

$9,979
Ian Hamilton Finlay
2012

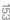

Looking back

How much do artists find themselves looking back to earlier works, or entire earlier chapters in their lives? Just as the long past can seem to be a foreign country, so one's own past is not always an easy or desirable place to revisit (for artists as much as anyone else). Sometimes artists have forgotten works or whole sequences of works, and encounter old pieces with a jolt of recognition, or a strange sensation of alienation. For others, looking back to former endeavours and ideas is a necessary and vital way of moving forwards.

Billy Childish
b.1959

And then life ticks on…

I think that as you get older, things have less potential. When you are young, everything has potential: people you might meet, the world, things that will be in your life. What does start to weigh, as you get older, is a lack of potential. Potential is diminishing all the time. So making a move opens up this enormous and unknown potential. [1]

Sarah Lucas
b.1962

Richard Wentworth
b.1947

No matter what your personal story or your tendency to embroider it, you have to take yourself seriously if you want to be taken seriously. Seriously, of course, can be a bore.

When I was younger, even before I was an artist, I would often aspire to ambivalence. But I was always tremendously excited, to the extent that I couldn't control myself about anything that happened in my life. And I would get really nervous.

David Shrigley
b.1968

'If you're too afraid of
making mistakes,
you'll never develop'
David Shrigley

Richard Wentworth

Last week, in the Arsenale in Venice, a couple came up to me and said 'If you can't improvise, you're fucked.' They then said it was their working mantra and I had said that in a commencement speech in San Francisco in 2002. It's nice to be recognized, but maybe nicer to be remembered. But, there again, I'm not so sure.

What I did, you see — my trick was I never wanted anything. So I never owned anything, I never had children, I never had mortgages, never did any of those things. The most I had was a guitar and an old ambulance — and I was quite content. I was quite content not to get anywhere in the art world. I'm very fortunate, because I've never looked for anyone's validation.

Billy Childish

David Shrigley

I've realized that time changes the way you perceive work. There are often whole bodies of work that I would like to buy back and destroy. One certainly makes mistakes. But if you're too afraid of making mistakes, you'll never develop.

God, going back into the past, all this history, this parade of paintings I've made… Sometimes I cannot bear looking at my older work. I'm so much more interested in what I'm doing now.

Fiona Rae
b.1963

'Sometimes I cannot bear looking at my older work'
Fiona Rae

Lynda Benglis
b.1941

Shows are all basically the same in a sense. If it's old work, I'm always surprised that I even did it. And if it's new work, I'm usually looking forward to seeing it in a different context. Sometimes I forget about what I actually experienced in the older work… the older work is really my way of marking time; even in the present, it's my way of marking time. I remember the events around those times usually. *2*

I look back a lot. There are many pathways or veins in my practice — seams which are being tapped or exploited. I still think there's room for improvement in terms of the clarity and the realization.

Conrad Shawcross
b.1977

Billy Childish

I was bullied all the time as a kid, and sexually abused when I was young, and told I was thick and stupid and ugly by my family. And really, the thing I don't understand is where I get this confidence from. Because I certainly haven't manufactured it. It's just God's grace that I just happen to be like this, exactly in the same way as I happen to be very creative. And I'm not in charge of any of it. I do think that we undervalue male energy and maturity, to our detriment, in society. There's been a very bad overreaction since the last war. We've swerved out of the lane of oncoming traffic into the ditch on the other side of the road: overcorrection is our speciality, as we can see politically in the world, with what goes on. We're crazy kids, us humans.

When I was younger, I was encouraged to want to feel that I was at the end of something — or that the end of something is really important, in that you've mastered something and are completely in control, and now you can produce a masterpiece. Whereas now, that's not the way I feel, or how I want to view the work. I want to feel as if it's all completely new, and I'm not in control of it.

David Shrigley

Lynda Benglis

I've changed, and things are always looking different. That's the natural state of an artist.

IT'S NICE TO BE RECOGNIZED. BUT MAYBE NICER TO BE REMEMBERED. BUT AGAIN, I'M NOT SURE.

Richard Wentworth

Mortality

Mortality is one of art's enduring and deathless themes, from the lolling figures on Etruscan sarcophagi to Poussin's *Et in Arcadia Ego* (1639) — a painting of peasants discovering the ominous Latin inscription ('I am here, even in Arcadia' — death's own utterance) in the sunny countryside. Then there is Damien Hirst's diamond skull, a glittering memento mori, or the more profoundly existential works of artists such as Miroslaw Balka and Christian Boltanski, who have squared up to the horrors of mass murder in the twentieth century. Art is in many cases a grappling with — or rationalization of — mortality. How do artists reflect on, or rationalize, their own mortality?

David Hockney
b.1937

Painting is an old man's art. *3*

Sarah Lucas

I haven't been someone who feels frightened by the thought of getting older, and have been disconcerted by people who do think like that. But of course, as you get older, you can realize why. It is typical of young people not to understand that because they are young. But you also have a kind of duty to yourself to make sure it isn't like that. Obviously you have ups and downs. That is another good thing about art in terms of reinventing yourself or reinventing your work and turning things around. It is what it always was for me, even from the beginning. Making a positive out of something that could be seen as a negative. You have to find a way to do it that is not only about the things you make, but also about your life. Because they go together, don't they? *4*

<

Francis Bacon
1909–1992

Even when one is in the strong sun, casting a black shadow, death is always with you. *5*

A few of my friends have died. I'm getting older. I'm not the mad bastard shouting at the world any more. *6*

Damien Hirst
b.1965

Jo Baer
b.1929

Age is horrible — you lose the power of your hands, you lose your memory. You do not lose your eye in the sense of what you're seeing. That does not age, and does not change. Your eyes change but your perception — your brain, in that sense — does not age. Which is probably why you have Titians and Rembrandts.

I see myself now, personally, in a very complicated part of my life — it's not mid, late, or early, it's basically nothing. I am one of those lucky artists who has been able to remain in exactly the same position as a human being as when I first jumped on to the ice floe. And luckily people have dropped sandwiches and cigarettes on the iceberg along the way, so I can sort of sit there. *7*

Lawrence Weiner
b.1942

Tracey Emin
b.1963

As you get older, life feels heavier, more cumbersome. Things get harder to carry around, literally and spiritually. *8*

'Your eyes change but your perception does not age'

Jo Baer

Edward Said, in his book *On Late Style* (2004), argued that what composers write at the end of their lives is often marked by 'intransigence, difficulty, and unresolved contradictions'. How does getting old affect an artist's work and outlook? Is it a passage from innocence to experience, or just a change of episode? In an art world that is often held to be fixated with youth, are there advantages to be had in getting on?

>

David Shrigley I might be asked to go to New York for some event, and refuse because I'd rather spend the weekend in Devon with my wife and dog. In a way, that's good. But in another way it's bad, because indifference isn't something to aspire to — it means that you've extracted all the good stuff from life, and you don't really care.

Art is a properly occult phenomenon; another one of the best and worst aspects of the gig. Because it's so spooky and boundless an undertaking, a whole life's labour could mean anything or nothing at all, though that's true of any life, and posterity is for the archaeologists/archivists — let's just hope they have more job security than we do. **Jesse Darling** b.1981

Richard Wentworth Students should be encouraged to see how episodic lives are and that you might have different talents and responsibilities at different periods. Change is good — it's also inevitable. So is death, but it doesn't need to be made histrionic by market-making artists. Innit.

Experience shows me I do come out of the 'down' moments, and that I will have another idea. **Fiona Rae**

David Shrigley I always just say to myself, 'Well, as long as it's not shit, then it's all right.'

'What's the point?' is the best question in the world, and the worst. **Richard Wentworth**

Howard Hodgkin 1932–2017 The older I get, the more dissatisfied with my work I become. It's too demanding for the sort of silly, sensitive person that I am. It makes me miserably unhappy. The only hope is to go on working. *9*

I think maturity is very undervalued. When Pete [Doig] and I were starting out, we thought we might get a lucky break at 50. Curiously, that's exactly what I got. I call it my overnight success. **Billy Childish**

Maggi Hambling b.1945 I don't think you can be an artist unless you're vulnerable. You can't paint vulnerability unless you are vulnerable yourself.

The key to longevity for artists is the constant redefinition of their work, and a constant ability to question and change oneself. **Thaddaeus Ropac** b.1960

Fiona Rae As an artist, you can't escape yourself. You can challenge yourself and try to be aware of the choices you're making. But ultimately, especially with something like painting, it's a self-portrait. Of course I've changed through the years, but there's lots of me that remains the same and familiar.

Lynda Benglis I can pause. I'm not sure I get better, but I do plan on hearing an inner voice tell me where to go next. I have to pause in order to think. It's not just about active process, it's all about the pauses. A little thing might tell me sometimes, like going to a museum and seeing an Ionic column.

As you get older, you don't have a filter: you can say whatever you want, and you don't give a shit what anybody thinks. **Joyce Pensato** b.1941

Jo Baer I have always admired men, and from all the men I have married or lived with or dated, I have taken whatever they're good at. I'm a good carpenter because I learned from them. I watched them, asked questions. I'm a good geologist because I knew one for a long time. I'm a good mountaineer, and so on and so forth.

'There's no better thing to have — unless it's more money'

Jo Baer

Artists tend to be beyond embarrassment the way little children tend to be beyond embarrassment. *10* **Carl Andre** b.1935

Joyce Pensato A couple of years ago I did a show at Petzel, and at the time I was moving, I had all my junk. I had always wanted to really crap-up a fancy gallery, junk it up. So I brought in all my stuff. But mostly, that was about finally accepting who I am, embracing it, and saying: 'This is who I am, you can accept it or not.' And I think you have to get older to feel that way, not to care a little bit. You can say or do whatever, and it's okay. Right now, I'm having the best time — making a couple of dollars, being accepted by peers, and getting opportunities to show at different places. What is better than that?

Actually, I am getting now to be the best thing there is, which is an artist's artist. Especially among the young ones. There's no better thing to have — unless it's more money. **Jo Baer**

Larry Poons b.1937 Our mind is a machine that has on file every impulse that it's possible to have. Say, a person like Turner, or Glenn Gould, the pianist: why does it excel to your ears? How come? Why is it so marvellous, and everything else is less marvellous, to you? Even what you're perplexed by can be as valid an emotion as anything else: it's all good. Any feeling that one gets has to be good. I think Wallace Stevens once said: 'The utmost must be good.'

WHAT'S THE POINT?' IS THE BEST QUESTION IN THE WORLD, AND THE WORST.

Richard Wentworth

Notes

1 Sarah Lucas, quoted in Sadie Coles, 'Situation', *POP* magazine, issue 24, Spring/Summer 2013
2 Lynda Benglis, quoted in Micah Hauser, 'An Interview with Lynda Benglis, "Heir to Pollock," on Process, Travel and Not Listening to What Other People Say', *Huffington Post*, 25 March 2015
3 In this he is quoting an old Chinese adage. See Marco Livingstone, 'The Road Less Travelled' in Marco Livingstone et al, *David Hockney: A Bigger Picture* (London: Royal Academy of Arts, 2012), 25 4 Lucas, 'Situation' 5 Francis Bacon, quoted in Richard Cork, 'A Visit to Bacon's Studio', 4 October 1971, reprinted in Richard Cork, *Everything Seemed Possible: Art in the 1970s* (New Haven and London: Yale University Press, 2003) 291 6 Damien Hirst, quoted in Sean O'Hagan, 'Damien Hirst: "I Still Believe Art Is More Powerful than Money"', *The Guardian*, 11 March 2012 7 Lawrence Weiner, quoted in 'Lawrence Weiner by Marjorie Welish', *BOMB 54*, Winter 1996 8 Tracey Emin, quoted in Rachel Cooke, 'Tracey Emin: "Where Does that Girl Go? Where Does that Youth Go?"', *The Observer,* 28 September 2014
9 Howard Hodgkin, 'In the Studio', *Daily Telegraph*, 10 June 2016 10 Carl Andre, quoted in Barbara Rose, 'Carl Andre', *Interview*, June/July 2013

Auction price details

Carl Andre, *36 Copper Square* (1968) — $2,165,000 (2008)
Francis Bacon, *Three Studies of Lucian Freud* (1969) — $142,405,000 (2013)
Jo Baer, *Untitled* (1966–70) — £167,000 (2015)
Phyllida Barlow, *Untitled: Riff, 101* (2016) — £25,000 (2016)
Lynda Benglis, *Kearny Street Bows and Fans* (1985) — $245,000 (2014)
Louise Bourgeois, *Spider* (1996; cast 1997) — $28,165,000 (2015)
Billy Childish, *Man in a Landscape – North Beach San Francisco* (2007) — £23,750 (2013)
Joseph Cornell, *Medici Slot Machine* (1943) — $7,781,000 (2014)
Michael Craig-Martin, *Las Meninas I* (2000) — £149,000 (2016)
Salvador Dalí, *Portrait de Paul Eluard* (1929) — £13,481,250 (2011)
Willem de Kooning, *Untitled XXV* (1977) — $66,327,500 (2016)
Marcel Duchamp, *Belle Haleine — Eau De Voilette* (1921) — 8,913,000€ (2009)
Tracey Emin, *My Bed* (1998) — £2,546,500 (2014)
Eric Fischl, *Dog Days* (1983) — $1,874,500 (2009)
Helen Frankenthaler, *Saturn Revisited* (1964) — $2,830,000 (2015)
Alberto Giacometti, *L'homme au doigt* (1947) — $141,285,000 (2015)
Gilbert & George, *To Her Majesty* (1973) — £1,889,250 (2008)
Philip Guston, *To Fellini* (1958) — $25,883,750 (2013)
Maggi Hambling, *George Always I* (2007–08) — £23,125 (2015)
Ian Hamilton Finlay, *Untitled* (no date) — £7,500 (2012)
Marsden Hartley, *Lighthouse* (1915) — $6,313,000 (2008)
Damien Hirst, *Lullaby Spring* (2002) — £9,652,000 (2007)
David Hockney, *Woldgate Woods, 24, 25, and 26 October 2006* (2006) — $11,712,500 (2016)
Howard Hodgkin, *Goodbye to the Bay of Naples* (1980–2) — £1,688,750 (2007)
Jenny Holzer, *Untitled with Selections from Truisms (Abuse of Power...)* (1987) — $881,000 (2008)
Winslow Homer, *Children on the Beach (Watching the Tide Go Out; Watching the Boats)* (1873) — $4,533,000 (2014)
Rachel Howard, *Red Painting* (2007) — £132,000 (2008)
Tess Jaray, *Summer House* (c. 1965) — 3,750€ (2011)
Derek Jarman, *Sightless* (1992) — £18,800 (2001)
Chantal Joffe, *Self-portrait with Esme* (2008) — £49,250 (2010)
Allen Jones, *Hatstand, Table and Chair* (1969) — £2,169,250 (2013)

Anish Kapoor, *Untitled* (2003) — £1,945,250 (2008)
Jeff Koons, *Balloon Dog (Orange)* (1994–2000) — $58,405,000 (2013)
Michael Landy, *A Commodity Is an Ideology Made Material* (1998) — £23,750 (2011)
Leonardo da Vinci, *Salvator Mundi* (c. 1500) — $450,312,500 (2017)
Sarah Lucas, *Ace in the Hole* (1998) — $905,000 (2014)
Bruce Nauman, *Henry Moore Bound to Fail, Back View* (1967) — $9,906,000 (2001)
Chris Ofili, *The Holy Virgin Mary* (1996) — £2,882,500 (2015)
Yoko Ono, *Play It By Trust* (1986–7) — $116,500 (2010)
Philippe Parreno, *My Room Is Another Fish Bowl* (2015) — $516,500 (2017)
Joyce Pensato, *Moto Mouth* (2009) — 64,000€ (2015)
Grayson Perry, *I Want to Be an Artist* (1996) — £632,750 (2017)
Pablo Picasso, *Les femmes d'Alger (Version 'O')* (1955) — $179,365,000 (2015)
Jackson Pollock, *Number 19, 1948* (1948) — $58,363,750 (2013)
Larry Poons, *Little Sangre de Christo* (1964) — $1,157,000 (2014)
Ged Quinn, *Gone to Yours* (2005) — £193,250 (2011)
Fiona Rae, *Figure 1i* (2014) — £56,250 (2015)
Robert Rauschenberg, *Johanson's Painting* (1961) — $18,645,000 (2015)
Auguste Rodin, *L'Éternel Printemps* (1884) — $20,410,000 (2016)
James Rosenquist, *Be Beautiful* (1964) — $3,301,000 (2014)
Dante Gabriel Rossetti, *A Christmas Carol* (1867) — £4,562,500 (2013)
Dieter Roth (with Björn Roth), *Caleidoscope* (no date) — 75,000€ (2014)
Jenny Saville, *Shift* (1996–7) — £6,813,000 (2016)
Richard Serra, *L.A. Cone* (1986) — $4,267,750 (2013)
Conrad Shawcross, *The Nervous System* (2003) — £61,875 (2013)
David Shrigley, *Mr Glove* (2001) — £4,750 (2012)
Luc Tuymans, *Rumour* (2001) — $2,699,750 (2013)
Vincent van Gogh, *Portrait du Dr. Gachet* (1890) — $82,500,000 (1990)
Giorgio Vasari, *The Pietà* (no date) — $574,500 (2000)
Mark Wallinger, *Q6* (1994–5) — £65,000 (2006)
Andy Warhol, *Silver Car Crash (Double Disaster)* (1963) — $105,445,000 (2017)
Lawrence Weiner, *Balls of Wood Balls of Iron* (1995) — $185,000 (2015)
Richard Wentworth, *Red Titch* (1989) — £4,500 (1990)
Christopher Wool, *Untitled (Riot)* (1990) — $29,930,000 (2015)

Index of quotations

Acknowledgements

I would like to thank, above all, the artists whom I have interviewed directly: the late Edward Allington, Jo Baer, Lynda Benglis, Charlie Billingham, Billy Childish, Jesse Darling, Gilbert & George, Nick Goss, Maggi Hambling, Rachel Howard, Tess Jaray, Chantal Joffe, Allen Jones, Mary Reid Kelley, Michael Landy, Sarah Lucas, Joyce Pensato, Larry Poons, Ged Quinn, Fiona Rae, Conrad Shawcross, David Shrigley, Luc Tuymans, Mark Wallinger, Richard Wentworth and Issy Wood. Thanks are due also to Raphael Gygax and Thaddaeus Ropac for their distinctive perspectives.

I would also like to express huge thanks to Andrew Roff, John Parton and Marc Valli at Laurence King Publishing, and particular thanks to Justine Schaller and Mason Wells at Bibliothèque Design.

First published in 2018 by
Laurence King Publishing Ltd
361–373 City Road
London EC1V 1LR
enquiries@laurenceking.com
www.laurenceking.com

This work was produced by Laurence King Publishing Ltd, London.

A catalogue record for this book is available from the British Library.

ISBN 978-1-78627-307-9

Senior editor Andrew Roff
Designer Bibliothèque

Printed in China